On *Time and Being*

Martin Heidegger

Works

Co-editors J. Glenn Gray
Colorado College

Joan Stambaugh
Hunter College of City University of New York

Also by Martin Heidegger

Being and Time
Discourse on Thinking
Hegel's Concept of Experience
Identity and Difference
What is Called Thinking?
On the Way to Language
Poetry, Language, Thought

On *Time and Being*

MARTIN HEIDEGGER

Translated by Joan Stambaugh

1817

HARPER & ROW, PUBLISHERS

New York, Evanston, San Francisco, London

FIRST EDITION

STANDARD BOOK NUMBER: 06-063855-9

LIBRARY OF CONGRESS CATALOG CARD NUMBER: 72-78334

Designed by Patricia Dunbar

Contents

Introduction

On *Time and Being* contains Heidegger's lecture on "Time and Being" together with a summary of six seminar sessions on that lecture—a lecture on "The End of Philosophy and the Task of Thinking," and a short retrospective piece on Heidegger's relation to phenomenology. This introduction will attempt to examine and clarify briefly the path from *Being and Time* to "Time and Being."

Taken from an external point of view, "Time and Being" is obviously the reversal of Heidegger's early major work, *Being and Time.* But the road from *Being and Time* to "Time and Being" is too subtle and too complex to allow us to speak of a mere reversal of the concepts of Being and time. For in the later lecture these "concepts" have undergone a profound change without, however, relinquishing their initial fundamental intention.

In *Being and Time* Heidegger moves from a phenomenological hermeneutic of human being toward a fundamental ontology of Being. In this work he uncovers layers of experience, analyzing things of nature *(Vorhandensein)*, artifacts *(Zuhandensein)*, and the core of human being in its basic structure of care. All three constitute the original, indissoluble unity of being-in-the-world. This unity has its heritage in Husserl's conception of consciousness as intentional-

ity. All consciousness is consciousness *of* something. Thus, there is no such thing as a worldless subject (exemplified by Descartes' *res cogitans*), nor is there world in any meaningful, phenomenological sense of that word without human being. One might call the root nature of human being awareness, an awareness that is concerned about its own being-in-the-world. On the basis of this concern about its own being-in-the-world, human being is then able to be concerned and take care of other beings. When Heidegger states that time is the condition of the possibility of care, so to speak its constitutive structure, he is basically still within the Kantian framework which principally asks the question: "What makes X possible?" It is the unity of the three ecstases of time—past, present, and future—that constitutes the fundamental "Outside-itself," the mysterious transparency and openness which characterize human awareness in contrast to the equally mysterious opacity of other beings. One might say, for example, that the lack of self-awareness of the animal is just as strange to us as our own self-awareness, but in a different way.

With the statement at the end of *Being and Time* that temporality, the basic structure of human being, is perhaps the horizon of Being, Heidegger implicitly relinquishes the question of causality and conditions of possibility, and embarks on the road toward overcoming metaphysics *and* ontology. To state that temporality is the horizon of Being is not the same as to state that Being is the cause or ground of time. Horizon has to do with directionality and openness, not with causality. After *Being and Time* Heidegger abandons the distinction between metaphysics as traditional philosophy, and fundamental ontology, the ontology of Being for which he was seeking. Henceforth, metaphysics, ontology, and theology are identical, characterized by the god of philosophy which is *causa sui* and the *summum ens*.

It is this kind of philosophy—metaphysics and onto-theology—which Heidegger wishes to give up, not overcome. When he writes about the end of philosophy he immediately raises the question of the task of thinking. The end of philosophy is *not* the end of thinking. Thinking must take the step-back out of metaphysics as the

history of Being and pay heed to Appropriation which is strictly non-metaphysical.

The focus of this lecture is on time and Being. What sort of transformation have these terms undergone now that they are to be thought in a non-metaphysical way? According to Heidegger, Being has been thought in traditional philosophy exclusively as a kind of *presence*. The manner of presence changes throughout the history of philosophy, not in the dialectical, calculable fashion of Hegel, but in sudden epochal transformations which cannot be plotted out in advance. Thus, Heidegger sketches the basic forms of Being in the history of philosophy: the One (the unifying unique One), the Logos (the gathering which preserves all things), *idea, ousia, energeia*, substance, actuality, perception, the monad, objectivity, the being posited or self-positing in the sense of the will of reason, love, spirit, power, the will to will in the eternal recurrence of the same*

Both Being and time are concepts which have a long history in the metaphysical tradition going back to Plato. In fact, Heidegger uses these two concepts to establish what metaphysics *is* in his conception of it: Metaphysics begins when Plato separates the realm of Being (the Forms or Ideas) and the realm of time (becoming, existence). Thus, Heidegger must take these two terms which *define* his conception of metaphysics and attempt to give them a non-metaphysical meaning. This is no small task. We are simply caught in metaphysical thinking. How can Being be thought other than as that which never changes? How can time be thought other than as the perishable, constantly changing realm of existence?

For the remainder of this introduction I shall confine myself to indicating what path Heidegger follows in the beginning steps of the step-back out of metaphysics.

Being. Terminologically speaking, this term begins to recede in favor of Heidegger's Appropriation, a term which has never before had a philosophical significance. The word Being is simply too bogged down with metaphysical connotations. But Heidegger still

*Cf. p. 7.

retains it in order to maintain the relation to his earlier formulation of the question of Being. In other words, the question is the same, but in "Time and Being" Heidegger is groping his way out of metaphysics. Appropriation does not designate a "realm" as does Being, but rather a relation, that of man and Being. What is radically new and non-metaphysical about Appropriation is not only that it is an "activity"*—a non-static process—Appropriation is non-metaphysical because in the relationship between man and Being as appropriated to each other, the relation is more fundamental than what is related.

Time. The traditional theory of time since Aristotle can be roughly described as a series of now-points. This is, of course, an oversimplification, but the fact remains that philosophers have grappled with the problem of time and ended up in perplexity. As Kant remarked, "time yields no shape," and this makes it more difficult to think than space. Perhaps one of the least fruitful aspects of the traditional theories of time was that it was treated parallel to space and thus "spatialized."

Heidegger had already moved away from this concept of time in *Being and Time.* Whatever a theory of time accomplishes, it must offer a *structure of occurrence.* The occurrence or event in *Being and Time* concerns the temporality of *Dasein* and its structure was very close to Husserl's *Phenomenology of Internal Time Consciousness* in its emphasis on the future as the primary mode of time.

The occurrence or event in "Time and Being" concerns the temporal character of Being itself. Far removed from phenomenology (Being cannot "appear" in any phenomenological sense) and from onto-theology, future as the withholding of presence and past as the refusal of presence grant and yield presence in a reciprocal relationship. Pre*sence* has replaced the present which can too easily be confused with the Aristotelian "now." Thus, Heidegger has succeeded in substituting a true dimensionality of time in contradistinction to the seriality of a string of nows. He is, so to speak, describing sheer

*(This Heidegger shares with most thinkers since the nineteenth century—Nietzsche, Bergson, and Whitehead, to name a few.)

occurrence without reference to a thing occurring; and, thus, occurrence incorporates "room" for man and Being to be appropriated to each other.

Appropriation (Being) and time nearly coalesce in this analysis without, however, simply collapsing into an indifferent sameness. Time is the way in which Appropriation appropriates. As for Appropriation, we can neither say that it *is* nor that it is given *(es gibt)*. This would be like deriving the stream from its source which can and cannot be named.

The One, which alone is wise, is willing and unwilling to be called by the name of Zeus (of Life).*

JOAN STAMBAUGH

*Heraclitus, B 32.

Time and Being

*T*he following lecture calls for a few words of introduction. If we were to be shown right now two pictures by Paul Klee, in the original, which he painted in the year of his death—the watercolor "Saints from a Window," and "Death and Fire," tempera on burlap —we should want to stand before them for a long while—and should abandon any claim that they be immediately intelligible.

If it were possible right now to have Georg Trakl's poem "Septet of Death" recited to us, perhaps even by the poet himself, we should want to hear it often, and should abandon any claim that it be immediately intelligible.

If Werner Heisenberg right now were to present some of his thoughts in theoretical physics, moving in the direction of the cosmic formula for which he is searching, two or three people in the audience, at most, would be able to follow him, while the rest of us would, without protest, abandon any claim that he be immediately intelligible.

Not so with the thinking that is called philosophy. That thinking is supposed to offer "worldly wisdom" and perhaps even be a "Way to the Blessed Life." But it might be that this kind of thinking is today placed in a position which demands of it reflec-

tions that are far removed from any useful, practical wisdom. It might be that a kind of thinking has become necessary which must give thought to matters from which even the painting and the poetry which we have mentioned and the theory of mathematical physics receive their determination. Here, too, we should then have to abandon any claim to immediate intelligibility. However, we should still have to listen, because we must think what is inevitable, but preliminary.

Therefore, we must be neither surprised nor amazed if the majority of the audience objects to the lecture. Whether a few will, now or later, be prompted by the lecture to think further on such matters, cannot be foreseen. We want to say something about the attempt to think Being without regard to its being grounded in terms of beings. The attempt to think Being without beings becomes necessary because otherwise, it seems to me, there is no longer any possibility of explicitly bringing into view the Being of what *is* today all over the earth, let alone of adequately determining the relation of man to what has been called "Being" up to now.

Let me give a little hint on how to listen. The point is not to listen to a series of propositions, but rather to follow the movement of showing.

What prompts us to name time and Being together? From the dawn of Western-European thinking until today, Being means the same as presencing. Presencing, presence speaks of the present. According to current representations, the present, together with past and future, forms the character of time. Being is determined as presence by time. That this is so could in itself be sufficient to introduce a relentless disquiet into thinking. This disquiet increases as soon as we set out to think through in what respect there is such a determination of Being by time.

In what respect? Why, in what manner and from what source does something like time have a voice in Being? Every attempt to think adequately the relation of Being and time with the help of the current and imprecise representations of time and Being immedi-

ately becomes ensnared in a hopeless tangle of relations that have hardly been thought out.

We name time when we say: every thing has its time. This means: everything which actually is, every being comes and goes at the right time and remains for a time during the time allotted to it. Every thing has its time.

But is Being a thing? Is Being like an actual being in time? Is Being at all? If it were, then we would incontestably have to recognize it as something which is and consequently discover it as such among other beings. This lecture hall *is*. The lecture hall *is* illuminated. We recognize the illuminated lecture hall at once and with no reservations as something that is. But where in the whole lecture hall do we find the "is"? Nowhere among things do we find Being. Every thing has its time. But Being is not a thing, is not in time. Yet Being as presencing remains determined as presence by time, by what is temporal.

What is in time and is thus determined by time, we call the temporal. When a man dies and is removed from what is here, from beings here and there, we say that his time has come. Time and the temporal mean what is perishable, what passes away in the course of time. Our language says with still greater precision: what passes away *with* time. For time itself passes away. But by passing away constantly, time remains as time. To remain means: not to disappear, thus, to presence. Thus time is determined by a kind of Being. How, then, is Being supposed to be determined by time? Being speaks out of the constancy of time's passing away. Nevertheless, nowhere do we find time as something that is like a thing.

Being is not a thing, thus nothing temporal, and yet it is determined by time as presence.

Time is not a thing, thus nothing which is, and yet it remains constant in its passing away without being something temporal like the beings in time.

Being and time determine each other reciprocally, but in such a manner that neither can the former—Being—be addressed as something temporal nor can the latter—time—be addressed as a being.

As we give thought to all this, we find ourselves adrift in contradictory statements.

(Philosophy knows a way out of such situations. One allows the contradictions to stand, even sharpens them and tries to bring together in comprehensive unity what contradicts itself and thus falls apart. This procedure is called dialectic. Supposing the contradictory statements about Being and about time could be reconciled by an encompassing unity, this indeed would be a way out—it would be a way out which evades the matters and the issues in question; for it allows itself to become involved neither with Being as such nor with time as such nor with the relation of the two. The question is totally excluded here of whether the relation of Being and time is a connection which can then be brought about by combining the two, or whether Being *and* time name a matter at stake from which both Being and time first result.)

But how can we become properly involved with this matter at stake named by the titles "Being and time," "time and Being"?

Answer: by cautiously thinking over the matters named here. Cautiously means at first: not hastily invading the matters with unexamined notions, but rather reflecting on them carefully.

But may we take Being, may we take time, as matters? They are not matters if "matter" means: something which is. The word "matter," "a matter," should mean for us now what is decisively at stake in that something inevitable is concealed within it. Being—a matter, presumably *the* matter of thinking.

Time—a matter, presumably *the* matter of thinking, if indeed something like time speaks in Being as presence. Being *and* time, time *and* Being, name the relation of both issues, the matter at stake which *holds* both issues toward each other and endures their relation. To reflect upon this situation is the task of thinking, assuming that thinking remains intent on persisting in its matter.

Being—a matter, but not a being.

Time—a matter, but nothing temporal.

We say of beings: they are. With regard to the matter "Being" and with regard to the matter "time," we remain cautious. We do not

say: Being is, time is, but rather: there is Being and there is time.[1] For the moment we have only changed the idiom with this expression. Instead of saying "it is," we say "there is," "It gives."

In order to get beyond the idiom and back to the matter, we must show how this "there is" can be experienced and seen. The appropriate way to get there is to explain what is given in the "It gives," what "Being" means, which—It gives; what "time" means, which —It gives. Accordingly, we try to look ahead to the It which—gives Being and time. Thus looking ahead, we become foresighted in still another sense. We try to bring the It and its giving into view, and capitalize the "It."

First, we shall think Being in order to think It itself into its own element.

Then, we shall think time in order to think it itself into its own element.

In this way, the manner must become clear how there is, It gives Being and how there is, It gives time. In this giving, it becomes apparent how that giving is to be determined which, as a relation, first holds the two toward each other and brings them into being.

Being, by which all beings as such are marked, Being means presencing. Thought with regard to what presences, presencing shows itself as letting-presence. But now we must try to think this letting-presence explicitly insofar as presencing is admitted. Letting shows its character in bringing into unconcealment. To let presence means: to unconceal, to bring to openness. In unconcealing prevails a giving, the giving that gives presencing, that is, Being, in letting-presence.

(To think the matter "Being" explicitly requires our reflection to follow the direction which shows itself in letting–presence. But from unconcealing speaks a giving, an It gives.)

1. "There is" is used here to translate the German idiom *"es gibt,"* literally "it gives," but with the idiomatic meaning "there is" as in the French *"il y a."* In his *Letter on Humanism,* commenting on the use of the idiom "there is," and in *Being and Time,* Heidegger writes: "The 'it' which here 'gives' is Being itself. The 'gives,' however, indicates the giving nature of Being granting its truth." (Tr.)

However, the giving named above remains just as obscure for us as the It named here which gives.

To think Being itself explicitly requires disregarding Being to the extent that it is only grounded and interpreted in terms of beings and for beings as their ground, as in all metaphysics. To think Being explicitly requires us to relinquish Being as the ground of beings in favor of the giving which prevails concealed in unconcealment, that is, in favor of the It gives. As the gift of this It gives, Being belongs to giving. As a gift, Being is not expelled from giving. Being, presencing is transmuted. As allowing-to-presence, it belongs to unconcealing; as the gift of unconcealing it is retained in the giving. Being *is* not. There is, It gives Being as the unconcealing; as the gift of unconcealing it is retained in the giving. Being *is* not. There is, It gives Being as the unconcealing of presencing.

This "It gives, there is Being" might emerge somewhat more clearly once we think out more decisively the giving we have in mind here. We can succeed by paying heed to the wealth of the transformation of what, indeterminately enough, is called Being, and at the same time is misunderstood in its core as long as it is taken for the emptiest of all empty concepts. Nor is this representation of Being as the *abstractum* par excellence given up in principle, but only confirmed, when Being as the *abstractum* par excellence is absorbed and elevated into the concreteness par excellence of the reality of the absolute Spirit—as was accomplished in the most powerful thinking of modern times, in Hegel's speculative dialectic, and is presented in his *Science of Logic.*

An attempt to think upon the abundance of Being's transformations secures its first foothold—which also shows the way—when we think Being in the sense of presencing.

(I mean think, not just parrot the words and act as if the interpretation of Being as presencing were a matter of course.)

But what gives us the right to characterize Being as presencing? This question comes too late. For this character of Being has long since been decided without our contribution, let alone our merit. Thus we are bound to the characterization of Being as presencing.

It derives its binding force from the beginning of the unconcealment of Being as something that can be said, that is, can be thought. Ever since the beginning of Western thinking with the Greeks, all saying of "Being" and "Is" is held in remembrance of the determination of Being as presencing which is binding for thinking. This also holds true of the thinking that directs the most modern technology and industry, though by now only in a certain sense. Now that modern technology has arranged its expansion and rule over the whole earth, it is not just the sputniks and their by-products that are circling around our planet; it is rather Being as presencing in the sense of calculable material that claims all the inhabitants of the earth in a uniform manner without the inhabitants of the non-European continents explicitly knowing this or even being able or wanting to know of the origin of this determination of Being. (Evidently those who desire such a knowledge least of all are those busy developers who today are urging the so-called underdeveloped countries into the realm of hearing of that claim of Being which speaks from the innermost core of modern technology.)

But we do not by any means perceive Being as presencing exclusively, primarily in the remembrance of the early presentation of the unconcealment of Being accomplished by the Greeks. We perceive presencing in every simple, sufficiently unprejudiced reflection on things of nature (*Vorhandenheit*) and artifacts (*Zuhandenheit*). Things of nature and artifacts are both modes of presencing. The vast reach of presencing shows itself most oppressively when we consider that absence, too, indeed absence most particularly, remains determined by a presencing which at times reaches uncanny proportions.

However, we can also note historically the abundance of transformations of presencing by pointing out that presencing shows itself as the *hen,* the unifying unique One, as the *logos,* the gathering that preserves the All, as *idea, ousia, energeia, substantia, actualitas, perceptio, monad,* as objectivity, as the being posited of self-positing in the sense of the will of reason, of love, of the spirit, of power, as the will to will in the eternal recurrence of the same. Whatever can be

noted historically can be found within history. The development of the abundance of transformations of Being looks at first like a history of Being. But Being does not have a history in the way in which a city or a people have their history. What is history-like in the history of Being is obviously determined by the way in which Being takes place and by this alone. After what has just been explained, this means the way in which It gives Being.

At the beginning of Being's unconcealment, Being, *einai, eon* is thought, but not the "It gives," "there is." Instead, Parmenides says *esti gar einai,* "For Being is."

Years ago, in 1947, in the *Letter on Humanism (Wegmarken,* p. 165), I noted with reference to this saying of Parmenides: "The *esti gar einai* of Parmenides is still unthought today." This note would like to point out for once that we must not rashly give to the saying "For Being is" a ready interpretation which makes what is thought in it inaccessible. Anything of which we say "it is" is thereby represented as a being. But Being is not a being. Thus the *esti* that is emphasized in Parmenides' saying cannot represent the Being which it names as some kind of a being. Translated literally, the *esti* thus emphasized does mean "it is." But the emphasis discerns in the *esti* what the Greeks thought even then in the *esti* thus emphasized and which we can paraphrase by: "It is capable." However, the meaning of this capability remained just as unthought, then and afterward, as the "It" which is capable of Being. To be capable of Being means: to yield and give Being. In the *esti* there is concealed the It gives.

In the beginning of Western thinking, Being is thought, but not the "It gives" as such. The latter withdraws in favor of the gift which It gives. That gift is thought and conceptualized from then on exclusively as Being with regard to beings.

A giving which gives only its gift, but in the giving holds itself back and withdraws, such a giving we call sending. According to the meaning of giving which is to be thought in this way, Being—that which It gives—is what is sent. Each of its transformations remains destined in this manner. What is historical in the history of Being is

determined by what is sent forth in destining, not by an indeterminately thought up occurrence.

The history of Being means destiny of Being in whose sendings both the sending and the It which sends forth hold back with their self-manifestation. To hold back is, in Greek, *epoche*. Hence we speak of the epochs of the destiny of Being. Epoch does not mean here a span of time in occurrence, but rather the fundamental characteristic of sending, the actual holding-back of itself in favor of the discernibility of the gift, that is, of Being with regard to the grounding of beings. The sequence of epochs in the destiny of Being is not accidental, nor can it be calculated as necessary. Still, what is appropriate shows itself in the destiny, what is appropriate shows itself in the belonging together of the epochs. The epochs overlap each other in their sequence so that the original sending of Being as presence is more and more obscured in different ways.

Only the gradual removal of these obscuring covers—that is what is meant by "dismantling"—procures for thinking a preliminary insight into what then reveals itself as the destiny of Being. Because one everywhere represents the destiny of Being only as history, and history only as a kind of occurrence, one tries in vain to intrepret this occurrence in terms of what was said in *Being and Time* about the historicity of man (*Dasein*) (not of Being). By contrast, the only possible way to anticipate the latter thought on the destiny of Being from the perspective of *Being and Time* is to think through what was presented in *Being and Time* about the dismantling of the ontological doctrine of the Being of beings.

When Plato represents Being as *idea* and as the *koinonia* of the Ideas, when Aristotle represents it as *energeia*, Kant as position, Hegel as the absolute concept, Nietzsche as the will to power, these are not doctrines advanced by chance, but rather words of Being as answers to a claim which speaks in the sending concealing itself, in the "there is, It gives, Being." Always retained in the withdrawing sending, Being is unconcealed for thinking with its epochal abundance of transmutations. Thinking remains bound to the tradition of the epochs of the destiny of Being, even when and especially when

it recalls in what way and from what source Being itself receives its appropriate determination, from the "there is, It gives Being." The giving showed itself as sending.

But how is the "It" which gives Being to be thought? The opening remark about the combination of "Time and Being" pointed out that Being as presence, as the present in a still undetermined sense, is characterized by a time-character and thus by time. This gives rise to the supposition that the It which gives Being, which determines Being as presencing and allowing-to-presence, might be found in what is called "time" in the title *Time and Being*.

We shall pursue this supposition and think about time. "Time" is familiar to us by way of current representations in the same way as "Being." But it is also unknown in the same way once we propose to explain what is peculiar to time. While we were just now thinking about Being, we found: what is peculiar to Being, that to which Being belongs and in which it remains retained, shows itself in the It gives and its giving as sending. What is peculiar to Being is not anything having the character of Being. When we explicitly think about Being, the matter itself leads us in a certain sense away from Being, and we think the destiny that gives Being as a gift. By noting this fact we are prepared to find that what is peculiar to time also can no longer be determined with the aid of the current characteristics of time as commonly represented. But the combination of time and Being contains the directive to explain time in its peculiarity in the light of what was said of Being. Being means: presencing, letting-be-present: presence. Thus we might read somewhere the notice: "The celebration took place in the presence of many guests." The sentence could be formulated just as well: "with many guests being present."

The present—as soon as we have named it by itself, we are already thinking of the past and the future, the earlier and the later as distinct from the now. But the present understood in terms of the now is not at all identical with the present in the sense in which the guests are present. We never say and we cannot say: "The celebration took place in the now of many guests."

But if we are to characterize time in terms of the present, we understand the present as the now as distinct from the no-longer-now of the past and the not-yet-now of the future. But the present speaks at the same time of presence. However, we are not accustomed to defining the peculiar character of time with regard to the present in the sense of presence. Rather, we represent time—the unity of present, past and future—in terms of the now. Even Aristotle says that that of time which *is,* that is, presences, is the actual now. Past and future are a *me on ti:* something which is not, though not an absolute nullity, but rather something present which lacks something. This lack is named with the "no longer now" and the "not yet now." Viewed in this way, time appears as the succession of nows, each of which, barely named, already disappears into the "ago" and is already being pursued by the "soon." Kant says of time thus represented: "It has only one dimension" (*Critique of Pure Reason,* A31, B47). Time familiar to us as the succession in the sequence of nows is what we mean when measuring and calculating time. It seems that we have calculated time immediately and palpably before us when we pick up a watch or chronometer, look at the hands, and say: "Now it is eight-fifty (o'clock)." We say "now" and mean time. But time cannot be found anywhere in the watch that indicates time, neither on the dial nor in the mechanism, nor can it be found in modern technological chronometers. The assertion forces itself upon us: the more technological—the more exact and informative —the chronometer, the less occasion to give thought first of all to time's peculiar character.

But where is time? *Is* time at all and does it have a place? Obviously, time is not nothing. Accordingly, we maintain caution and say: there is time. We become still more cautious, and look carefully at that which shows itself to us as time, by looking ahead to Being in the sense of presence, the present. However, the present in the sense of presence differs so vastly from the present in the sense of the now that the present as presence can in no way be determined in terms of the present as the now. The reverse would rather seem possible. (Cf. *Being and Time,* section 81.) If such were the case, the present

as presence and everything which belongs to such a present would have to be called real time, even though there is nothing immediately about it of time as time is usually represented in the sense of a succession of a calculable sequence of nows.

But we have so far omitted showing more clearly what the present in the sense of presence means. Presence determines Being in a unified way as presencing and allowing-to-presence, that is, as unconcealing. What matter are we thinking when we say presencing? To presence means to last. But we are too quickly content to conceive lasting as mere duration, and to conceive duration in terms of the customary representation of time as a span of time from one now to a subsequent now. To talk of presencing, however, requires that we perceive biding and abiding in lasting as lasting in present being. What is present concerns us, the present, that is: what, lasting, comes toward us, us human beings.

Who are we? We remain cautious in our answer. For it might be that that which distinguishes man as man is determined precisely by what we must think about here: man, who is concerned with and approached by presence, who, through being thus approached, is himself present in his own way for all present and absent beings.

Man: standing within the approach of presence, but in such a way that he receives as a gift the presencing that It gives by perceiving what appears in letting-presence. If man were not the constant receiver of the gift given by the "It gives presence," if that which is extended in the gift did not reach man, then not only would Being remain concealed in the absence of this gift, not only closed off, but man would remain excluded from the scope of: It gives Being. Man would not be man.

Now it looks as if the reference to man had led us astray from the way upon which we would like to think about what is peculiar to time. In a way this is so. Yet we are closer than we believe to the matter which is called time and which is to show itself explicitly in the light of the present as presence.

Presence means: the constant abiding that approaches man, reaches him, is extended to him. But what is the source of this

extending reach to which the present belongs as presencing, insofar as there is presence? True, man always remains approached by the presencing of something actually present without explicitly heeding presencing itself. But we have to do with absence just as often, that is, constantly. For one thing, there is much that is no longer present in the way we know presencing in the sense of the present. And yet, even that which is no longer present presences immediately in its absence—in the manner of what has been, and still concerns us. What has been does not just vanish from the previous now as does that which is merely past. Rather, what has been presences, but in its own way. In what has been, presencing is extended.

But absence also concerns us in the sense of what is not yet present in the manner of presencing in the sense of coming toward us. To talk of what is coming toward us has meanwhile become a cliché. Thus we hear: "the future has already begun," which is not so, because the future never just begins since absence, as the presencing of what is not yet present, always in some way already concerns us, is present no less immediately than what has been. In the future, in what comes toward us, presencing is offered.

If we heed still more carefully what has been said, we shall find in absence—be it what has been or what is to come—a manner of presencing and approaching which by no means coincides with presencing in the sense of the immediate present. Accordingly, we must note: Not every presencing is necessarily the present. A curious matter. But we find such presencing, the approaching that reaches us, in the present, too. In the present, too, presencing is given.

How are we to determine this giving of presencing that prevails in the present, in the past, in the future? Does this giving lie in this, that it reaches us, or does it reach us because it is in itself a reaching? The latter. Approaching, being not yet present, at the same time gives and brings about what is no longer present, the past, and conversely what has been offers future to itself. The reciprocal relation of both at the same time gives and brings about the present. We say "at the same time," and thus ascribe a time character to the

mutual giving to one another of future, past and present, that is, to their own unity.

This procedure is obviously not in keeping with the matter, assuming that we must give the name "time" to the unity of reaching out and giving which we have now shown, to this unity alone. For time itself is nothing temporal, no more than it is something that is. It is thus inadmissible to say that future, past and present are before us "at the same time." Yet they belong together in the way they offer themselves to one another. Their unifying unity can be determined only by what is their own; that they offer themselves to one another. But what do they offer to one another?

Nothing other than themselves—which means: the presencing that is given in them. With this presencing, there opens up what we call time-space. But with the word "time" we no longer mean the succession of a sequence of nows. Accordingly, time-space no longer means merely the distance between two now-points of calculated time, such as we have in mind when we note, for instance: this or that occurred within a time-span of fifty years. Time-space now is the name for the openness which opens up in the mutual self-extending of futural approach, past and present. This openness exclusively and primarily provides the space in which space as we usually know it can unfold. The self-extending, the opening up, of future, past and present is itself prespatial; only thus can it make room, that is, provide space.

Time-space as commonly understood, in the sense of the distance measured between two time-points, is the result of time calculation. In this calculation, time represented as a line and parameter and thus one-dimensional is measured out in terms of numbers. The dimensionality of time, thought as the succession of the sequence of nows, is borrowed from the representation of three-dimensional space.

But prior to all calculation of time and independent of such calculation, what is germane to the time-space of true time consists in the mutual reaching out and opening up of future, past and present. Accordingly, what we call dimension and dimensionality in a way easily misconstrued, belongs to true time and to it alone. Dimension-

ality consists in a reaching out that opens up, in which futural approaching brings about what has been, what has been brings about futural approaching, and the reciprocal relation of both brings about the opening up of openness. Thought in terms of this threefold giving, true time proves to be three-dimensional. Dimension, we repeat, is here thought not only as the area of possible measurement, but rather as reaching throughout, as giving and opening up. Only the latter enables us to represent and delimit an area of measurement.

But from what source is the unity of the three dimensions of true time determined, the unity, that is, of its three interplaying ways of giving, each in virtue of its own presencing? We already heard: In the approaching of what is no longer present and even in the present itself, there always plays a kind of approach and bringing about, that is, a kind of presencing. We cannot attribute the presencing to be thus thought to one of the three dimensions of time, to the present, which would seem obvious. Rather, the unity of time's three dimensions consists in the interplay of each toward each. This interplay proves to be the true extending, playing in the very heart of time, the fourth dimension, so to speak—not only so to speak, but in the nature of the matter.

True time is four-dimensional.

But the dimension which we call the fourth in our count is, in the nature of the matter, the first, that is, the giving that determines all. In future, in past, in the present, that giving brings about to each its own presencing, holds them apart thus opened and so holds them toward one another in the nearness by which the three dimensions remain near one another. For this reason we call the first, original, literally incipient extending in which the unity of true time consists "nearing nearness," "nearhood" (*Nahheit*), an early word still used by Kant. But it brings future, past and present near to one another by distancing them. For it keeps what has been open by denying its advent as present. This nearing of nearness keeps open the approach coming from the future by withholding the present in the approach. Nearing nearness has the character of denial and withholding. It

unifies in advance the ways in which what has-been, what is about to be, and the present reach out toward each other.

Time *is* not. There is, It gives time. The giving that gives time is determined by denying and withholding nearness. It grants the openness of time-space and preserves what remains denied in what has-been, what is withheld in approach. We call the giving which gives true time an extending which opens and conceals. As extending is itself a giving, the giving of a giving is concealed in true time.

But where *is* there time and time-space, where are they given? As urgent as this question may be at first sight, we may no longer ask in this manner for a where, for the place for time. For true time itself, the realm of its threefold extending determined by nearing nearness, is the prespatial region which first gives any possible "where."

True, from its beginning, whenever it thought about time, philosophy also asked where time belongs. What philosophy primarily had in view was time calculated as a sequence of the succession of consecutive nows. It was explained that there could be no numerically measured time with which we calculate without the *psyche,* without the *animus,* without the soul, without consciousness, without spirit. There is no time without man. But what does this "not without" mean? Is man the giver or the receiver of time? Is man first of all man, and then after that occasionally—that is, at some time or other —receives time and relates himself to it? True time is the nearness of presencing out of present, past and future—the nearness that unifies time's threefold opening extending. It has already reached man as such so that he can be man only by standing within the threefold extending, perduring the denying, and withholding nearness which determines that extending. Time is not the product of man, man is not the product of time. There is no production here. There is only giving in the sense of extending which opens up time-space.

But granted that the manner of giving in which time is given requires our characterization of time, we are still faced with the enigmatic It which we named in the expression: It gives time; It gives Being. There is a growing danger that when we speak of "It," we

arbitrarily posit an indeterminate power which is supposed to bring about all giving of Being and of time. However, we shall escape indeterminancy and avoid arbitrariness as long as we hold fast to the determinations of giving which we attempted to show, if only we look ahead toward Being as presence and toward time as the realm where, by virtue of offering, a manifold presencing takes place and opens up. The giving in "It gives Being" proved to be a sending and a destiny of presence in its epochal transmutations.

The giving in "It gives time" proved to be an extending, opening up the four-dimensional realm.

Insofar as there is manifest in Being as presence such a thing as time, the supposition mentioned earlier grows stronger that true time, the fourfold extending of the open, could be discovered as the "It" that gives Being, i.e., gives presence. The supposition appears to be fully confirmed when we note that absence, too, manifests itself as a mode of presence. What has-been which, by refusing the present, lets that become present which is no longer present; and the coming toward us of what is to come which, by withholding the present, lets that be present which is not yet present—both made manifest the manner of an extending opening up which gives all presencing into the open.

Thus true time appears as the "It" of which we speak when we say: It gives Being. The destiny in which It gives Being lies in the extending of time. Does this reference show time to be the "It" that gives Being? By no means. For time itself remains the gift of an "It gives" whose giving preserves the realm in which presence is extended. Thus the "It" continues to be undetermined, and we ourselves continue to be puzzled. In such cases it is advisable to determine the It which gives in terms of the giving that we have already described. This giving proved to be the sending of Being, as time in the sense of an opening up which extends.

(Or are we puzzled now only because we have allowed ourselves to be led astray by language or, more precisely, by the grammatical interpretation of language; staring at an It that is supposed to give, but that itself is precisely not there. When we say "It gives Being,"

"It gives time," we are speaking sentences. Grammatically, a sentence consists of a subject and a predicate. The subject of a sentence is not necessarily a subject in the sense of an ego or a person. Grammar and logic, accordingly, construe it-sentences as impersonal, subject-less sentences. In other Indo-Germanic languages, in Greek and Latin, the It is lacking, at least as a separate word and phonetic form; but that does not mean that what is meant by the It is not also in their thought: in Latin, *pluit,* it is raining; in Greek, *chre,* it is needful.

But what does this "It" mean? Philologists and philosophers of language have given the matter much thought without arriving at any valid clarification. The area of meaning meant by the It extends from the irrelevant to the demonic. The "It" of which we speak when we say "It gives Being," "It gives time," presumably indicates something distinctive which we shall not discuss here. We shall be content, therefore, with a fundamental consideration.

Interpreted by the rules of grammar and logic, that about which a statement is made appears as the subject: *hypokeimenon*—that which already lies before us, which is present in some way. What is then predicated of the subject appears as what is already present along with the present subject, the *symbebekos, accidens:* "The auditorium is illuminated." In the "It" of "It gives" speaks a presence of something that is present, that is, there speaks, in a way, a Being. If we substitute Being for It in our sentence "It gives Being," it says as much as "Being gives Being." And here we are back in the same difficulty that we mentioned at the beginning of the lecture: Being is. But Being "is" just as little as time "is." We shall therefore now abandon the attempt to determine "It" by itself, in isolation, so to speak. But this we must keep in mind: The It, at least in the interpretation available to us for the moment, names a presence of absence.

When we say "It gives Being," "It gives time," we are not making statements about beings. However, the syntax of sentences as we have it from the Greek and Roman grammarians has such statements exclusively in view. In view of this fact we must also consider the possibility that, contrary to all appearances, in saying "It gives Be-

ing." "It gives time," we are not dealing with statements that are always fixed in the sentence structure of the subject-predicate relation. And yet, how else are we to bring the "It" into view which we say when we say "It gives Being," "It gives time"? Simply by thinking the "It" in the light of the kind of giving that belongs to it: giving as destiny, giving as an opening up which reaches out. Both belong together, inasmuch as the former, destiny, lies in the latter, extending opening up.

In the sending of the destiny of Being, in the extending of time, there becomes manifest a dedication, a delivering over into what is their own, namely of Being as presence and of time as the realm of the open. What determines both, time and Being, in their own, that is, in their belonging together, we shall call: *Ereignis,* the event of Appropriation. *Ereignis* will be translated as Appropriation or event of Appropriation. One should bear in mind, however, that "event" is not simply an occurrence, but that which makes any occurrence possible. What this word names can be thought now only in the light of what becomes manifest in our looking ahead toward Being and toward time as destiny and as extending, to which time and Being belong. We have called both—Being and time—"matters." The "and" between them left their relation to each other indeterminate.

We now see: What lets the two matters belong together, what brings the two into their own and, even more, maintains and holds them in their belonging together—the way the two matters stand, the matter at stake—is Appropriation. The matter at stake is not a relation retroactively superimposed on Being and time. The matter at stake first appropriates Being and time into their own in virtue of their relation, and does so by the appropriating that is concealed in destiny and in the gift of opening out. Accordingly, the It that gives in "It gives Being," "It gives time," proves to be Appropriation. The statement is correct and yet also untrue: it conceals the matter at stake from us; for, unawares, we have represented it as some present being, whereas in fact we are trying to think presence as such. But could it not be that we might suddenly be relieved of all the difficulties, all these complicated and seemingly fruitless discus-

sions, by raising and answering this simple and long-overdue question: What is the event of appropriation?

At this point we must be permitted an interim question: What is meant here by "answering," by "answer"? Answer means the Saying that co-responds to the matter at stake which we must think here, to Appropriation. But if the matter at stake prohibits our speaking of it by way of a statement, then we must give up the declaratory sentence that is anticipated by the question we have raised. But to do so means to admit our inability to think fittingly what has to be thought here. Or would it be more advisable to give up not just the answer, but even the question? How about this convincingly justified and candidly posed question: What is Appropriation? The question asks for whatness, for the essence, it asks how Appropriation becomes present, how it presences.

Our seemingly innocent question, What is Appropriation? demands information about the Being of Appropriation. But if Being itself proves to be such that it belongs to Appropriation and from there receives its determination as presence, then the question we have advanced takes us back to what first of all demands its own determination: Being in terms of time. This determination showed itself as we looked ahead to the "It" that gives, looked through the interjoined modes of giving: sending and extending. Sending of Being lies in the extending, opening and concealing of manifold presence into the open realm of time-space. Extending, however, lies in one and the same with sending, in Appropriating. This, that is, the peculiar property of Appropriation, determines also the sense of what is here called "lying."

What we have said now allows and in a way even compels us to say how Appropriation must *not* be thought. What the name "event of Appropriation" names can no longer be represented by means of the current meaning of the word; for in that meaning "event of Appropriation" is understood in the sense of occurrence and happening—not in terms of Appropriating as the extending and sending which opens and preserves.

Thus, we heard it proclaimed recently that the agreement reached

Being itself and follow what is its own, Being proves to be destiny's gift of presence, the gift granted by the giving of time. The gift of presence is the property of Appropriating. Being vanishes in Appropriation. In the phrase "Being as Appropriation," the word "as" now means: Being, letting–presence sent in Appropriating, time extended in Appropriating. Time and Being appropriated in Appropriation. And Appropriation itself? Can we say anything more about it?

Along the way, we have already thought more about it, although it was not explicitly said: namely, that to giving as sending there belongs keeping back—such that the denial of the present and the withholding of the present, play within the giving of what has been and what will be. What we have mentioned just now—keeping back, denial, withholding—shows something like a self-withdrawing, something we might call for short: withdrawal. But inasmuch as the modes of giving that are determined by withdrawal—sending and extending—lie in Appropriation, withdrawal must belong to what is peculiar to the Appropriation. This, however, no longer belongs to the matter of this lecture.

(Briefly, and inadequately as is the way of a lecture, we would here point out what is peculiar to Appropriation.

(The sending in the destiny of Being has been characterized as a giving in which the sending source keeps itself back and, thus, withdraws from unconcealment.

(In true time and its time-space, the giving of what has-been, that is, of what is no longer present, the denial of the present manifested itself. In the giving of future, that is, of what is not yet present, the withholding of the present manifested itself. Denial and withholding exhibit the same trait as self-withholding in sending: namely, self-withdrawal.

(Insofar as the destiny of Being lies in the extending of time, and time, together with Being, lies in Appropriation, Appropriating makes manifest its peculiar property, that Appropriation withdraws what is most fully its own from boundless unconcealment. Thought in terms of Appropriating, this means: in that sense it expropriates

within the European economic community was a European event of
world-historic significance. Now, if the word "event" is heard in the
context of a discussion of Being, and if we take the word only in its
current meaning, it becomes almost inevitable to speak of the event
of Being. For without Being, no being is capable of being as such.
Accordingly, Being can be proffered as the highest, most significant
event of all.

However, the sole purpose of this lecture was to bring before our
eyes Being itself as the event of Appropriation. But what the word
"Appropriation" denotes says something altogether different. The
inconspicuous word "as," always treacherous because of its several
meanings, must also be thought accordingly. Even assuming that in
our discussion of Being and time we abandon the common meaning
of the word "event" and instead adopt the sense that suggests itself
in the sending of presence and the extending of time-space which
opens out—even then our talk about "Being as Appropriation"
remains indeterminate.

"Being as the event of Appropriation": Formerly, philosoph
thought Being in terms of beings as *idea, energeia, actualitas,* will-
and now, one might think, as Appropriation. Understood in th
way, "Appropriation" means a transformed interpretation of Bei
which, if it is correct, represents a continuation of metaphysics.
this case, the "as" signifies: Appropriation as a species of Bei
subordinated to Being which represents the leading concept tha
retained. But if we do what was attempted, and think Being in
sense of the presencing and allowing-to-presence that are ther
destiny—which in turn lies in the extending of true time w
opens and conceals—then Being belongs into Appropriating.
ing and its gift receive their determination from Appropriatin
that case, Being would be a species of Appropriation, and n
other way around.

To take refuge in such an inversion would be too cheap
thinking misses the matter at stake. Appropriation is not the e
passing general concept under which Being and time could
sumed. Logical classifications mean nothing here. For as w

itself of itself. Expropriation belongs to Appropriation as such. By this expropriation, Appropriation does not abandon itself—rather, it preserves what is its own.

(We catch sight of the other peculiar property in Appropriation as soon as we think clearly enough what has already been said. In Being as presence, there is manifest the concern which concerns us humans in such a way that in perceiving and receiving it we have attained the distinction of human being. Accepting the concern of presence, however, lies in standing within the realm of giving. In this way, four-dimensional true time has reached us.

(Because Being and time are there only in Appropriating, Appropriating has the peculiar property of bringing man into his own as the being who perceives Being by standing within true time. Thus Appropriated, man belongs to Appropriation.

(This belonging lies in the assimilation that distinguishes Appropriation. By virtue of this assimilation, man is admitted to the Appropriation. This is why we can never place Appropriation in front of us, neither as something opposite us nor as something all-encompassing. This is why thinking which represents and gives account corresponds to Appropriation as little as does the saying that merely states.)

Since time as well as Being can only be thought from Appropriation as the gifts of Appropriation, the relation of space to Appropriation must also be considered in an analogous way. We can admittedly succeed in this only when we have previously gained insight into the origin of space in the properties peculiar to site and have thought them adequately. (Cf. "Building Dwelling Thinking" in *Poetry, Language, Thought,* translated by Albert Hofstadter, Harper & Row 1971.) The attempt in *Being and Time,* section 70, to derive human spatiality from temporality is untenable.

True, as we look through Being itself, through time itself, and look into the destiny of Being and the extending of time-space, we have glimpsed what "Appropriation" means. But do we by this road arrive at anything else than a mere thought-construct? Behind this suspicion there lurks the view that Appropriation must after all "be"

something. However: Appropriation neither *is,* nor *is* Appropriation *there.* To say the one or to say the other is equally a distortion of the matter, just as if we wanted to derive the source from the river. What remains to be said? Only this: Appropriation appropriates. Saying this, we say the Same in terms of the Same about the Same. To all appearances, all this says nothing. It does indeed say nothing so long as we hear a mere sentence in what was said, and expose that sentence to the cross-examination of logic. But what if we take what was said and adopt it unceasingly as the guide for our thinking, and consider that this Same is not even anything new, but the oldest of the old in Western thought: that ancient something which conceals itself in *a-letheia?* That which is said before all else by this first source of all the *leitmotifs* of thinking gives voice to a bond that binds all thinking, providing that thinking submits to the call of what must be thought.

The task or our thinking has been to trace Being to its own from Appropriation—by way of looking through true time without regard to the relation of Being to beings.

To think Being without beings means: to think Being without regard to metaphysics. Yet a regard for metaphysics still prevails even in the intention to overcome metaphysics. Therefore, our task is to cease all overcoming, and leave metaphysics to itself.

If overcoming remains necessary, it concerns that thinking that explicitly enters Appropriation in order to say It in terms of It about It.

Our task is unceasingly to overcome the obstacles that tend to render such saying inadequate.

The saying of Appropriation in the form of a lecture remains itself an obstacle of this kind. The lecture has spoken merely in propositional statements.

Summary of a Seminar
on the Lecture
"Time and Being"

*B*y way of introduction, many things were referred to which could serve as an aid to a better understanding of the lecture, and thus facilitate the preparation and anticipate the seminar's intention. These references already touched upon the questions and themes which in the meetings to follow were partly made explicit and partly determined the path of the seminar while remaining in the background.

On account of the peculiarity of what was discussed, this seminar was an experiment. It was essentially different from the seminars which Heidegger has given in the course of his academic career. Expressed more superficially, this difference is already evident in the fact that Heidegger's own text forms the basis of the seminar, not a text of metaphysics. In the attempt to discuss what was said in the lecture, something more daring than the lecture itself became evident. The lecture's risk lies in the fact that it speaks in propositional statements about something essentially incommensurable with this kind of saying. However, we must heed the fact that it is not a matter of mere statements, but of an answering prepared by questions, an answering which attempts to adapt itself to the matter with which it is concerned. Everything—statements, questions, and answers—pre-

supposes *the experience of the matter itself.*

The experimental quality of the seminar was thus twofold: on the one hand, it wanted to point directly at a matter which in accordance with its very nature is inaccessible to communicative statements. On the other hand, it had to attempt to prepare the participants for their own experience of what was said in terms of an experience of something which cannot be openly brought to light. It is thus the attempt to speak of something that cannot be mediated cognitively, not even in terms of questions, but must be experienced. The attempt to speak of it with the intention of preparing for this experience essentially constituted the daring quality of the seminar.

The intention of the seminar aimed at bringing the lecture to view as a whole, its fundamental plan, as well as the context of the lecture within Heidegger's thinking in general. The need also arose of gaining clarity about the situation of philosophy today, at a time when Heidegger's thinking ex-sists, and which on the other hand can be characterized by the decline of philosophy. This decline has many faces. Inasmuch as philosophy is understood as metaphysics, the decline is manifest in the fact that the matter of thinking is no longer the matter of metaphysics, although metaphysics itself presumably remains. The substitutes for philosophy are already becoming apparent, the possibilities of sidestepping it: on the one hand, mere interpretation of the traditional philosophical texts, the polishing and dismantling of metaphysics, on the other hand, the replacement of philosophy by logic (logistics), psychology, and sociology, in short, by anthropology.

In this seminar we had to presuppose the knowledge and the experience of the history of metaphysics, since we could not explicitly refer to historical connections and individual metaphysical positions. Hegel was an exception. We specifically dealt with him because of the remarkable fact that Heidegger's thinking has been compared with Hegel's again and again in the most various ways. Although in point of fact Hegel is in a way further from Heidegger's concern than any other metaphysical position, the illusion of an identity, and thus of a comparability, of the two positions intrudes

itself in an almost compulsory manner. How so? What does the speculative development of Being (qua "object") to Being (qua "concept") mean? How does "Being" maintain itself as "presence" here? Why does the "thought" as speculative dialectic correspond to that? Looking back upon Hegel's discussion of "Being," it is necessary for the clarification of Heidegger's own path and for the understanding of his thinking to distinguish him from Hegel, not just by denying the similarity, but by trying to throw light on the reason for the illusion of that similarity.

Following these preliminary remarks about the seminar—its peculiar character, its intention, and the presupposed knowledge of metaphysics—we approached the lecture itself.

Its place within the whole of Heidegger's endeavors was made evident by a characterization of his path.

The lecture entitled "Time and Being" asks first about what is peculiar to Being, then about what is peculiar to time. It became clear that neither Being nor time *is.* Thus we reached the transition to the "It gives." The "It gives" was discussed first with regard to giving, then with regard to the It that gives. The It was interpreted as Appropriation. More succinctly formulated: The lecture goes from *Being and Time* past what is peculiar to "Time and Being" to the It that gives, and from this to Appropriation.

With the necessary caution, one could say that the lecture repeats the movement and the transformation of Heidegger's thinking in *Being and Time* to the later Saying of Appropriation. What happens in this movement? What does the transformation of questioning and answering which has occurred in Heidegger's thinking look like?

Being and Time is the attempt to interpret Being in terms of the transcendental horizon of time. What does "transcendental" mean here? It does not mean the objectivity of an object of experience as constituted in consciousness, but rather the realm of projection for the determination of Being, that is, presencing as such, caught sight of from the opening up of human being (Da-sein). In the lecture "Time and Being," the meaning of time, as yet unthought, which lies in Being as presencing, is anchored in a still more original

relation. Talking about something more original can easily be mis-understood here. But even if we leave open for the time being the question of how what is more original is to be understood, and that means how it is not to be understood, the fact remains that this thinking—indeed in the lecture itself as well as in the whole of Heidegger's course of thought—has the character of return. That is the step back. One should note the ambiguity of the phrase. In talking about "back," it is necessary to discuss where we go back, and how.

The question can then be asked, however, whether and how this return constituting the manner of movement of this thinking is related to the fact that Appropriation is not only sending, but as sending is actually withdrawal.

Is the character of withdrawal already evident in the problems of *Being and Time?* In order to see this, we must enter the simple intention of this work, that is, the meaning which time has in the question about the meaning of Being. Time, which is addressed as the meaning of Being in *Being and Time,* is itself not an answer, not a last prop for questioning, but rather itself the naming of a question. The name "time" is a preliminary word for what was later called "the truth of Being."

The interpretation of time aims primarily at the character of tem-poralization of *Dasein's* temporality, at the ecstatic element which in itself already contains a reference to truth, to opening up, to the unconcealment of Being qua Being, even though this is not explicitly named in the part of *Being and Time* which was published (see *Being and Time,* section 28). Thus already in *Being and Time* time is from the very beginning removed from the common conception by the reference to *aletheia* and presencing, and receives a new meaning, although the interpretation of time is limited here to the temporality of *Dasein,* and there is no mention of the temporal character of Being. (In contrast, the role of human being for the opening out of Being is purposely left out in the lecture "Time and Being.")

Thus it is a matter of avoiding the limitation which might, indeed at first does, lie in the word "time," both in "Time and Being" where this is explicitly done and also in *Being and Time* where it

occurs more in the general tenor and unspoken intention. Already in *Being and Time,* time is thought in its relation to *aletheia* (unconcealment) and in terms of the Greek *ousia* (presence).

If this is how it is with time—time being addressed as the transcendental horizon of Being—then how can the fundamental experience guiding the position of *Being and Time* be characterized? Is it possible to find the character of withdrawal already in that position? The experience which attempts to find expression for the first time in *Being and Time* and which in its transcendental manner of questioning must still in a way speak the language of metaphysics has indeed thought the Being of beings and brought it to a conceptual formulation, thus also bringing the truth of beings to view, but in all these manifestations of Being, the truth of Being, its truth as such, has never attained to language, but has remained in oblivion. The fundamental experience of *Being and Time* is thus that of the oblivion of Being. But oblivion means here in the Greek sense: concealment and self-concealing.

The oblivion of Being which is manifest as not thinking about the truth of Being can easily be interpreted and misunderstood as an omission of previous thinking, in any case as something which would be terminated by the question about the meaning, that is, the truth of Being when that question is explicitly adopted and followed through. Heidegger's thinking could be understood, and *Being and Time* still suggests this—as the preparation and beginning of a foundation upon which all metaphysics rests as its inaccessible ground, in such a way that the preceding oblivion of Being would thus be overcome and negated. However, for the correct understanding it is a matter of realizing that this previous non-thinking is not an omission, but is to be thought as the consequence of the self-concealment of Being. As the privation of Being, the concealment of Being belongs to the opening up of Being. The oblivion of Being which constitutes the essence of metaphysics and became the stimulus for *Being and Time* belongs to the essence of Being itself. Thus there is put to the thinking of Being the task of thinking Being in such a way that oblivion essentially belongs to it.

The thinking that begins with *Being and Time* is thus, on the one

hand, an awakening from the oblivion of Being—an awakening which must be understood as a recollection of something which has never been thought—but on the other hand, as this awakening, not an extinguishing of the oblivion of Being, but placing oneself in it and standing within it. Thus the awakening from the oblivion of Being to the oblivion of Being is the awakening into Appropriation. The oblivion of Being can first be experienced as such in the thinking on Being itself, on Appropriation.

The character of this thinking was often called the "step back." At first this step back is understood as an "away from" and a "toward." Thus Heidegger's thinking would be the movement away from the openness of beings toward openness as such which remains concealed in manifest beings. However, something else is thought in the phrase "step back." The step steps back before, gains distance from that which is about to arrive. The gaining of distance is a removal of distance, the freeing of the approach of what is to be thought.

In the step back, openness as such appears as what is to be thought. But in what direction does it shine? Thought in terms of the step back, where does that step lead us? The "whither" cannot be determined. It can only be determined in the taking of the step back, that is, it can only result from corresponding to that which appears in the step back.

With regard to the indeterminacy of this "whither," a fundamental difficulty became evident. Does this indeterminacy exist only for knowledge in such a way that the place of appearance is in itself determined, but still concealed from knowledge? If, on the other hand, this indeterminacy exists not only for knowledge, but is rather an indeterminacy of the manner of being of the "whither" itself, then the question arises of how such an indeterminacy can be thought which is not to be understood merely in terms of the need of our not yet knowing.

To the extent that this was clarified, one could say in spite of the inadequacy of these expressions: The "that" of the place of the "whither" is certain, but as yet how this place is, is concealed from

knowledge. And it must remain undecided whether the "how," the manner of Being of this place, is already determined (but not yet knowable) or whether it itself results only from the taking of the step, in the awakening into Appropriation which we mentioned.

We attempted once more to characterize the fundamental intention and movement of the lecture. This led again to a reflection on *Being and Time.*

From the point of view of metaphysical thinking, the whole path of the lecture, that is, the determination of Being, in terms of Appropriation could be interpreted as a return to the ground, to the origin. The relation of Appropriation and Being would then be the relation of the *a priori* to the *a posteriori.* This *a priori* is not to be understood only as the *a priori* of and for knowledge which has become dominant in modern philosophy. It would be a matter of a causal nexus which could be more precisely determined in Hegel's sense as the reabsorption and incorporation of Being in Appropriation.

This interpretation was also plausible on account of the term "fundamental ontology" used to characterize the intention and the method of *Being and Time*—a term which was then dropped precisely with the intention of countering this misunderstanding. The decisive thing which must be heeded here is the relation of fundamental ontology to the sole question of the meaning of Being prepared for in *Being and Time.* According to *Being and Time,* fundamental ontology is the ontological analysis of *Dasein.*

"Therefore *fundamental ontology,* from which alone all other ontologies can take their rise, must be sought in the *existential analytic of Dasein"* (Being and Time, p. 34). According to this, it looks as if fundamental ontology were the foundation for ontology itself which is still lacking, but is to be built upon that foundation. When it is a matter of the question about the meaning of Being, whereas meaning is projected meaning which occurs in and as the understanding of Being which constitutes the fundamental characteristic of *Dasein,* then the development of *Dasein's* horizon of understanding is the condition for any development of an ontology which, so it seems, can only be built upon the fundamental ontology of *Dasein.*

Thus the relation of fundamental ontology to the clarification of the meaning of Being—which was not published—would be analogous to the relation between fundamental theology and theological system.

This, however, is not true, although it cannot be denied that this is not yet clearly expressed in *Being and Time* itself. Rather, *Being and Time* is on the way toward finding a concept of time, toward that which belongs most of all to time, in terms of which "Being" gives itself as presencing. This is accomplished on the path of the temporality of *Dasein* in the interpretation of Being as temporality. But this means that what is fundamental in fundamental ontology is incompatible with any building on it. Instead, after the meaning of Being had been clarified, the whole analytic of Dasein was to be more originally repeated in a completely different way.

Thus, since the foundation of fundamental ontology is no foundation upon which something could be built, no *fundamentum inconcussum,* but rather a *fundamentum concussum,* and since the repetition of the analytic of Dasein already belongs to the point of departure of *Being and Time* whereas the word "foundation" contradicts the preliminary character of the analytic, the term "fundamental ontology" was dropped.

At the end of the first session, some passages of the text were discussed which are not easy to understand and which are indispensable for an understanding of the lecture.

At the end of the introduction to the lecture, the paragraph "Our task is . . . to sufficiently determine" caused some difficulties.

First of all there is a huge contradiction in the sentence: "The attempt to think Being without beings becomes necessary because otherwise, it seems to me, there is no longer any possibility of bringing explicitly into view the Being of what *is* today all over the earth." The necessity and the possibility of this contradiction is related to the ambiguity of Framing *(Gestell)* about which we are thinking when we use the phrase "the Being of that which . . . *is* today." As the preliminary appearance of Appropriation, Framing is in addition that which makes this attempt necessary. Thus the neces-

sity of understanding the present time is not the true motivation for our attempt, as one might at first believe from the text.

Then we asked whether the expression "the Being of what *is* today all over the *earth*" does not signify a narrowing down of the universal problem of Being to the small planet, the tiny grain of sand which is called earth, whether this narrowing down does not stem from an anthropological interest. This question was not pursued further. We did not explain how Framing, which constitutes the essence of modern technology, hence of something that, as we know, only occurs on earth, can be a name for universal Being.

Then the phrase "to think Being without beings" was discussed. Along with the expression used on page 24 "without regard to the relation of Being to beings," this phrase is the abbreviated formulation of: "to think Being without regard to grounding Being in terms of beings." "To think Being without beings" thus does not mean that the relation to beings is inessential to Being, that we should disregard this relation. Rather, it means that Being is not to be thought in the manner of metaphysics, which consists in the fact that the *summum ens* as *causa sui* accomplishes the grounding of all beings as such (cf. Leibniz' so-called twenty-four metaphysical theses in Heidegger, *Nietzsche,* Vol. II, pp. 454 ff.). But we mean more than this. Above all, we are thinking of the metaphysical character of the ontological difference according to which Being is thought and conceived for the sake of beings, so that Being, regardless of being the ground, is subjugated to beings.

The first sentences of the lecture—after the introduction—also caused some difficulties.

At first it was stated directly: "Ever since the beginning of Western European thinking up to today, Being means the same as presence." What about this statement? Does Being mean presence exclusively or in any case with so much priority that its other characteristics can be passed by? Does the determination of Being as presence, which is the only determination stressed in the lecture, result merely from the lecture's intention to think Being and time together? Or does presence have in the totality of Being's determi-

nations a "factual" priority independent of the intention of the lecture? Above all, how about the determination of Being as ground?

Presencing, presence speaks in all metaphysical concepts of Being, speaks in all determinations of Being. Even the ground as what already lies present, as what underlies, leads, when considered in itself, to lasting, enduring, to time, to the present.

Not only in the Greek determination of Being, but, for example, also in the Kantian "position" and in the Hegelian dialectic as the movement of *thesis,* anti*thesis* and syn*thesis* (here again a being-posited) the present speaks, the priority of presencing makes itself known (cf. *Nietzsche* II, pp. 311 ff., further: *Wegmarken* 1967, pp. 273 ff. "Kant's Thesis on Being").

These intimating references show a priority of presence which has its say in all formulations of Being. How, in what manner this determination is, what the meaning of the priority of presence making itself known is, is still unthought. The priority of presence thus remains an assertion in the lecture "Time and Being," but as such a *question* and a task of thinking: to consider whether and whence and to what extent the priority of presence exists.

The first paragraphs of the lecture continue following the sentence just cited: "Presencing, presence speaks of the present." This is ambiguous. On the one hand, it can be understood to mean that presencing as presence is thought in relation to the perceiver and his *repraesentio.* The present would then be a *determination resulting from* presencing and would name the relation of presencing to perceiving man. On the other hand, it can be understood to mean that—quite generally—time speaks from presencing. Here it remains open how and in what manner. "Being is determined as presence by time." This second meaning is what the lecture intends. However, the ambiguity and the difficulty of the exposition of the problem—thus the fact that in the first sentences we have to do not with an inference, but with the first groping around in the thematic realm—tends to lead to misunderstandings whose removal is possible only by continually keeping the theme of the lecture as a whole in view.

At the beginning of the second session, some things were added to the general remarks with which the seminar began.

a. The belonging of the relation of Being and thinking together with the question of Being.

Although the relation of Being and thinking—or Being and man—is not explicitly discussed in the lecture, we must keep in mind the fact that it belongs essentially to every step of the question of Being. Here we must note a double role of thinking. The thinking which essentially belongs to the openness of Being is, on the one hand, the thinking which distinguishes man. In terms of *Being and Time,* it can be called *understanding* thinking. On the other hand, thinking is interpretative thinking, the thinking which thinks the relation of Being and thinking, and the question of Being in general.

We must consider whether thinking in the first sense can characterize the peculiarity of interpretative thinking, the way in which "philosophical" thinking belongs to the question of Being. It remains questionable whether interpretation can be what is characteristic of thinking at all when it is a matter of truly taking upon ourselves the question of Being. The task for thinking is that of freeing itself and keeping itself free for what is to be thought in order to receive its determination from that.

b. Provisionalness.

A further characteristic of the thinking which is also decisive for the realization of the question of Being is closely bound up with the fact that thinking receives its decisive determination only when it enters Appropriation. Echoes of this can already be found in the discussion of the step back. This characteristic is its provisionalness. Above and beyond the most obvious meaning that this thinking is always merely preparatory, provisionalness has the deeper meaning that this thinking always anticipated—and this in the mode of the step back. Thus the emphasis on the provisional character of these considerations does not stem from any kind of pretended modesty, but rather has a strict, objective meaning which is bound up with the finitude of thinking and of what is to be thought. The more stringently the step back is taken, the more adequate anticipatory Saying becomes.

c. The various paths to Appropriation.

Appropriation has already been spoken of in earlier writings:

1. In the *Letter on Humanism* where the Appropriation is already spoken of, but still with a conscious ambiguity.

2. Appropriation is spoken of more unequivocally in the four lectures given in 1949 under the collective title "Insight into that which is." These lectures, as yet unpublished except for the first and last ones, are entitled "The Thing, das Gestell, die Gefahr, The Turn." (Cf. *Lectures and Essays* 1954, pp. 163 ff. "The Thing").

3. In the lecture on technology which is not merely another version of the lecture just mentioned, "das Gestell" (*op. cit.*, pp. 13 ff. "die Frage nach der Technik"; further: *Opuscula*, "Die Technik und die Kehre" 1962).

4. Most clearly in the lecture on identity. *Identity and Difference* (Harper & Row 1969, trans. by Joan Stambaugh).

These passages were called to mind with the intention of stimulating reflection on the differences and the belonging together of the paths to Appropriation previously pointed out.

Next, the critical passage (on p. 5) which is important for the path and way of the lecture was the subject of more intensive consideration. It was a question of the paragraph: "Being, by which" up to "that is, gives Being."

At first the word "marked" ("Being, by which all beings as such are marked") was discussed, a word which was very carefully chosen in order to name Being's effect upon beings. To mark—related to showing—points to the contour, the gestalt, so to speak, the what-gestalt as it were, which is native to beings as such. With regard to beings, Being is that which shows, makes something visible without showing itself.

The paragraph in question continues: "Thought with regard to what presences, presencing shows itself as letting-presence insofar as presence is admitted."

The crux of the passage is the "But now" which sharply delineates what follows from what preceded and announces the introduction of something new.

To what is the difference related which becomes evident in the

of confirming mere existence. This is evident in poetic language. Trakl says:

> It is a light which the wind has extinguished.
> It is a jug which a drunkard leaves in the afternoon.
> It is a vineyard, burned and black with holes full of spiders.
> It is a room which they have whitewashed.

These verses are in the first stanza of the poem "Psalm." In another poem called "De Profundis," which belongs to the same cycle as the first poem, Trakl says:

> It is a stubble field on which a black rain falls.
> It is a brown tree which stands alone.
> It is a hissing wind which circles around empty huts.
> How sad this evening.
>
> . . .
> . . .
>
> It is a light which is extinguished in my mouth.

And Rimbaud says in a passage from "Les Illuminations":

> Au bois il y a un oiseau, son chant vous arrête et vous fait rougir.
> Il y a une horloge qui ne sonne pas.
> Il y a une fondrière avec un nid de bêtes blanches.
> Il y a une cathédrale que descend et un lac qui monte.
> Il y a une petite voiture abandonée dans le taillis, ou qui descend le sentier en courant, enrubannée.
> Il y a une troupe de petits comédiens en costumes, aperçus sur la route á travers la lisière du bois.
> Il y a enfin, quand l'on a faim et soif, quelqu'un qui vous chasse.
>
> In the woods there's a bird whose singing stops you and makes you blush.
> There's a clock which doesn't strike.

> There's a clay-pit with a nest of white animals.
> There's a cathedral coming down and a lake going up.
> There's a little carriage abandoned in the woods or rolling down the path, with ribbons all over it.
> There's a troupe of child actors, in costumes, whom you can see on the road through the edge of the wood.
> And then there's someone who chases you off when you're hungry and thirsty.*

The French *il y a* (cf. the phrase of South German dialect *es hat,* "it has") corresponds to the German *es gibt,* "it gives." Presumably, Trakl was familiar with Rimbaud's poem just cited.

We clarified somewhat the "it is" of poetic language which Rilke and Benn also use. First we can say that "It is" confirms the existence of something just as little as the "It gives" does. In contradistinction to the customary one, the "It gives," the "It is" does not name the availability of something which is, but rather precisely something unavailable, what concerns us as something uncanny, the demonic. Thus the relation to man is also named in the "It is" far more emphatically than in the customary "It gives."

What this "It is" means can only be thought in terms of Appropriation. Thus this remained an open question, similar to the relation between the poetic "It is" and the "It gives" belonging to thought.

A few grammatical discussions about the It in "It gives," about the kind of sentences characterized by grammar as impersonal sentences without a subject, and also a short reminder about the Greek metaphysical foundations of the interpretation of the sentence as a relation of subject and predicate, today a matter of course, hinted at the possibility of understanding the saying of "It gives Being," "It gives time" other than as prepositional statements.

In this context two questions were discussed which had been raised about the lecture. One had to do with the possible end of the history of Being, the other with the manner of Saying adequate to Appropriation.

Re 1. If Appropriation is not a new formation of Being in the

*Translation by Wallace Fowlie, Harvill Press, London, 1953.

history of Being, but if it is rather the case that Being belongs to Appropriation and is reabsorbed in it (in whatever manner), then the history of Being is at an end for thinking *in* Appropriation, that is, for the thinking which enters into Appropriation—in that Being, which lies in sending—is no longer what is to be thought explicitly. Thinking then stands in and before That which has sent the various forms of epochal Being. This, however, what sends as Appropriation, is itself unhistorical, or more precisely without destiny.

Metaphysics is the history of the formations of Being, that is, viewed from Appropriation, of the history of the self-withdrawal of what is sending in favor of the destinies, given in sending, of an actual letting-presence of what is present. Metaphysics is the oblivion of Being, and that means the history of the concealment and withdrawal of that which gives Being. The entry of thinking into Appropriation is thus equivalent to the end of this withdrawal's history. The oblivion of Being "supersedes"[1] itself in the awakening into Appropriation.

But the concealment which belongs to metaphysics as its limit must belong to Appropriation itself. That means that the withdrawal which characterized metaphysics in the form of the oblivion of Being now shows itself as the dimension of concealment itself. But now this concealment does not conceal itself. Rather, the attention of thinking is concerned with it.

With the entry of thinking into Appropriation, its own way of concealment proper to it also arrives. Appropriation is in itself *expropriation*. This word contains in a manner commensurate with Appropriation the early Greek *lethe* in the sense of concealing.

Thus the lack of destiny of Appropriation does not mean that it has no "movement." Rather, it means that the manner of movement most proper to Appropriation turning toward us in withdrawal—first shows itself as what is to be thought.[2]

This means that the history of Being as what is to be thought is at an end for the thinking which enters the Appropriation—even if

1. *hebt auf.* (Tr.)
2. *Das zu Denkende.* (Tr.)

metaphysics should continue to exist, something which we cannot determine.

Re 2. The other question is related to what we have just said, the question of what might be given to thinking in Appropriation as a task for thought and accordingly what the adequate way of Saying might be. We are not only asking about the form of Saying—about the fact that speaking in propositional statements is inadequate for what is to be said—but, roughly expressed, about the content. In the lecture it was said: "What remains to be said? Only this: Appropriation appropriates." At first this only wards off the manner in which Appropriation is *not* to be thought. Expressed positively, the question arises: What does Appropriation appropriate? What is appropriated by Appropriation? And: When thinking thinks Appropriation, is it pondering what is appropriated by Appropriation?

Nothing is said about this in the lecture itself which only wants to pave the way to Appropriation. But in other writings of Heidegger's some thought has been given to this.

Thus, at the end of the lecture on Identity[3] it is stated what Appropriation appropriates, that is, brings into its own and retains in Appropriation: namely, the belonging together of Being and man. In this belonging together, what belongs together is no longer Being and man, but rather—as appropriated—mortals in the fourfold of world. The lecture "Hölderlin's Earth and Sky" *(Hölderlin Jahrbuch* 1960, pp. 17 ff.) and the lecture "The Thing" speak in different ways about what is appropriated, about the fourfold. In addition, everything that was said about language as Saying belongs here (*On the Way to Language,* 1971).

Thus Heidegger has spoken about Appropriation and what it appropriates, although only in a preliminary preparatory way. For this thinking can only be concerned with preparing the entry into Appropriation. The fact that one can only say of Appropriation that Appropriation appropriates does not exclude, but rather includes a whole wealth of what is to be thought in Appropriation itself. All

3. Cf. "The Law of Identity" in *Identity and Difference.* (Tr.)

the more so in that in the relation to man, thing, gods, earth and sky, thus in the relation to what is appropriated, we must never forget that expropriation belongs essentially to Appropriation. But this includes the question: Expropriation in what direction? The direction and meaning of this question was not discussed any further.

At the beginning of the fourth session, another question led again to a consideration of the intention of the lecture.

In the *Letter on Humanism* (Klostermann edition, p. 23) we read: "For the It which gives here is Being itself." The objection arose that this unequivocal statement did not agree with the lecture "Time and Being" in that the intention of thinking Being as Appropriation led to a predominance of Appropriation, to the disappearance of Being. The disappearance of Being not only conflicted with the passage in the *Letter on Humanism,* but also with the passage in the lecture where it was stated that the sole intention of the lecture was "to bring Being itself as Appropriation to view."

To this we answered first that in the passage in question in the *Letter on Humanism* and thus almost throughout, the term "Being itself" already names Appropriation. (The relations and contexts constituting the essential structure of Appropriation were worked out between 1936 and 1938). Secondly, it is precisely a matter of seeing that Being, by coming to view as Appropriation, disappears as Being. Thus there is no contradiction between the two statements. Both name the same matter with differing emphasis.

It is also not possible to say that the title of the lecture "Time and Being" contradicts the disappearance of Being. This title wants to announce the continuation of the thinking of *Being and Time.* It does not mean that "Being" and "Time" are retained, and as such must again become thematic at the end of the lecture.

Rather, Appropriation is to be thought in such a way that it can neither be retained as Being nor as time. It is, so to speak, a *"neutrale tantum,"* the neutral "and" in the title "time and Being." However, this does not exclude the fact that sending and giving are also explic-

itly thought in Appropriation, so that Being and time, too, in a way continue to be thematic.

The passages in *Being and Time* were mentioned in which "It gives" was already used without being directly thought in relation to Appropriation. These passages appear today as half attempts— attempts to work out the question of Being, attempts to give that question the adequate direction. But they themselves remain inadequate. Thus our task today is to see the themes and motives in these attempts which point to the question of Being and are determined by that question. Otherwise, one easily makes the mistake of regarding the investigations of *Being and Time* as independent studies which are then rejected as insufficient. Thus, for example, the question of death is pursued solely within the boundaries and motives which result from the intention of working out the temporality of *Dasein.*

Even today it is very hard to imagine the scope of the difficulties which stood in the way of asking the question of Being, its point of departure and its development. Within the framework of the Neokantian philosophy of that time, a philosophy had to fulfill the claim of thinking in a Kantian way, critically, transcendentally, if it was to find an audience as a philosophy. Ontology was a word of scorn. Husserl himself who came close to the true question of Being in the *Logical Investigations*—above all in the VI—could not persevere in the philosophical atmosphere of that time. He came under the influence of Natorp and turned to transcendental phenomenology which reached its first culmination in the *Ideas.* The principle of phenomenology was thus abandoned. Philosophy's invasion (in the form of Neo–kantianism) of phenomenology caused Scheler and many others to leave Husserl. It remains an open question whether and how this secession followed the principle of "back to things of thought."

All of this has been mentioned in order to clarify possible questions about the manner of procedure of the lecture. This procedure can be called phenomenological if one understands by phenomenology not a particular school of philosophy, but rather something which permeates every philosophy. This something can best be

called by the well-known motto "To the things themselves." It was precisely in this sense that Husserl's investigations stood out from the manner of procedure of Neo–kantianism as something new and tremendously stimulating, as Dilthey was the first (1905) to see. And it is in this sense that one can say of Heidegger that he preserves true phenomenology. Actually, the question of Being would not have been possible without a fundamentally phenomenological attitude.

Husserl's turn toward the problems of Neo–kantianism—first evident in the important essay "Philosophy as Exact Science" (*Logos* I, 1910–11) which is much too neglected today—and the fact that Husserl lacked any vital relation to history brought about the break with Dilthey. In this connection, we mentioned among other things the fact that Husserl understood *Being and Time* as the regional ontology of the historical within the framework of his conception of regional ontologies.

The fourth session was dominated by the discussion of a question related to the important passage ("Being by . . ." up to "that is, gives Being") which we already cited. The question aimed at the relation of Being and time to Appropriation and asked whether there was a gradation in the sense of an ever greater originality within the concepts named there—presencing, letting-presence, unconcealing, giving and appropriating. It asked whether the movement in the passage in question leading from presencing to letting-presence etc. to appropriating was a deduction to a more original ground.

If it is not a case of something more original, the question arises of what the difference and relation is between the concepts named. They do not present a gradation, but rather stages on a way back which is opened and leads preliminarily into Appropriation.

The discussion following essentially concerned the meaning of determination inherent in the manner in which presencing determines what is present in metaphysics. Through this articulation, the character of the way back from presencing to appropriating was to be clarified, a character which can only too easily be misunderstood as the preparation of a more original ground.

The presencing of what is present—that is, letting-presence: what

is present—is interpreted by Aristotle as *poiesis*. Later interpreted as *creatio*, this leads in a straight line of admirable simplicity up to positing, as the transcendental consciousness of objects. Thus it becomes evident that the fundamental characteristic of the letting-presence of metaphysics is production in its various forms. In contrast, we showed that the determining relation in Plato between presencing and what is present is not to be understood as *poieses*, although the "poetical" character of *nous* comes more and more to the foreground—above all in the *Laws*. In *to kalo ta kala kala*, only the *parousia*, the being together of the *kalon* with the *kala* is expressed without the meaning of the "poietic" with regard to what is present being attributed to this being together. And that shows that for Plato, the determination remains unthought. For nowhere does he work out what the true *parousia* is, nowhere does he say what the *parousia* accomplishes with relation to the *onta*. This gap is not closed by the fact that Plato tries to grasp the relation of presencing to what is present in the light metaphor, that is, not as *poiesis*, making etc., but as light. In this he is undoubtedly close to Heidegger. For the letting-presence thought by Heidegger is a bringing-into-the-open, although in the passage in question of the lecture it is and must be meant neutrally and openly against all kinds of making, constitution etc. In this the Greek element, light and radiance, has become explicit. But we must still ask what the metaphorical reference to light would like to say, but as yet cannnot say.

With the relation of letting-presence to *aletheia*, the whole question about the Being of beings is removed from the Kantian framework of the constitution of objects, although even the Kantian position is to be understood in retrospect in terms of *aletheuein*. The emphasis on the imagination in the book on Kant bears witness to this.

At this point the question was asked whether it was sufficient to understand the relation of presencing to what is present as unconcealing, if unconcealing is taken for itself, that is, if it is not determined with regard to content. If unconcealing already lies in all kinds of *poiesis*, of making, of effecting, how can one exclude these

modes and keep unconcealing purely for itself? What, then, does this unconcealing mean when it is not determined with regard to content? In reference to this, an important distinction was made between the unconcealing, which, for example, belongs to *poiesis,* and the unconcealing which Heidegger means. Whereas the first is related to *eidos*—this is what is set apart, unconcealed in *poiesis*—what Heidegger thinks with unconcealing is related to the totality of beings. Then the distinction between That-ness and What-ness, whose origin is obscure and unclarified, was mentioned (cf. Heidegger, *Nietzsche* II, pp. 399 ff.).

However, concerning the intention of the questions under consideration, it was said that the various modes of unconcealing which are determined with regard to content remain to be thought, although unconcealing in the passage in question is kept only as a fundamental trait. Thus the character of effecting is removed from the letting in letting-presence. With the step from presencing to letting-presence, and from there to unconcealing, nothing is decided about the character of presence in the different regions of beings. The task remains for thinking to determine the unconcealment of the different regions of things.

The same kind of movement which lies in the step from presencing to letting-presence is evident in the transition from letting-presence to unconcealing and from there to giving. In each case, thinking takes the step back. Thus the manner of procedure of this thinking could be viewed analogously to the method of a negative theology. That is also evident in the fact that, and the manner in which, ontic models given in language are used up and destroyed. For example, the usage of verbs is remarkable, verbs such as "reach," "send," "withhold," "appropriate," words which not only have a temporal form in general as verbs, but over and above that show a marked termporal meaning for something which is not temporal.

The fifth session began with Jean Beaufret's report whose function it was to serve as a foundation for the discussion of the repeatedly asserted similarity between Heidegger's and Hegel's thinking. The

speaker reported on the manner in which this similarity is viewed in France.

At first, a closeness and a striking similarity between Heidegger and Hegel is not to be denied. Thus in France the impression was widely predominant that Heidegger's thinking was a recapitulation —as a deepening and an expansion—of Hegel's philosophy, just as Leibniz represented a recapitulation of Descartes, or Hegel a recapitulation of Kant. If one fundamentally views Heidegger's thinking in this perspective, then one could undeniably find unequivocal correspondences between all aspects of Heidegger's thinking and those of Hegel's philosophy. With the help of these correspondences one could, so to speak, set up a table of concordances and thus find out that Heidegger says pretty much the same as Hegel. But this whole view presupposes that there is such a thing as Heidegger's philosophy. If that were not the case, then every comparison would lose the basis of its comparability. Yet impossibility of comparison is not equivalent to unrelatedness.

In the second part of the report, some of the grossest misunderstandings which Heidegger's thinking encountered in France were mentioned. In Hegel's *Logic,* Being as the immediate is mediated to essence as the truth of Being. Is this path from Being to essence, and from essence to concept, is this path to the truth of Being originally introduced as the immediate the same or in any case comparable to the question of Being developed in *Being and Time?* How can one attempt to grasp the fundamental difference?

From Hegel's point of view, one could say: *Being and Time* gets caught in Being. It doesn't develop Being to the "concept"—(an assertion which is *externally* supported by Hegel's terminology: Being—essence—concept). On the other hand, the question could at once be asked from the perspective of *Being and Time* with regard to Hegel's thinking: How does Hegel come to posit Being as indeterminate immediacy and thus from the very beginning to place it in relation to determination and mediation? (Cf. Heidegger, *Wegmarken,* 1967, pp. 255 ff. "Hegel and the Greeks.")

This last question gave occasion for an excursus on the unclarified

problem of the origin of Hegelian negativity. Is the "negativity" of Hegelian logic grounded in the structure of absolute consciousness, or is it the other way around? Is speculative reflection the ground for the negativity which for Hegel belongs to Being, or is negativity also the ground for the absoluteness of consciousness? If one notes that Hegel works with original dualisms in the *Phenomenology* which are harmonized only later on (beginning with the *Logic*), and if the concept of life as developed in Hegel's early writings is referred to, the negativity of the negative apparently cannot be derived from the reflection structure of consciousness, although on the other hand, the fact cannot be ignored that the modern point of departure from consciousness has contributed a great deal to the development of negativity. Negation could rather be related to the idea of being torn and thus, objectively speaking, go back to Heraclitus (*diapheron*).

The difference in the point of departure in the determination of Being was established in the following two points:

1. That which for Hegel determines Being in its truth is never questioned in this philosophy, because for Hegel the identity of Being and thinking is really an equivalence. Thus for Hegel there is no *question* of Being, and no such question can even arise.

2. Starting with the lecture in which it was shown that Being is appropriated in Appropriation, one might be tempted to compare Appropriation as the ultimate and the highest with Hegel's Absolute. But back behind this illusion of identity one would then have to ask: for Hegel, how is man related to the Absolute? And: what is the manner of relatiòn of man to Appropriation? Then one would see an unbridgeable difference. Since for Hegel man is the place of the Absolute's coming-to-itself, that coming-to-itself leads to the overcoming of man's finitude. For Heidegger, in contrast, it is precisely finitude that comes to view—not only man's finitude, but the finitude of Appropriation itself.

The discussion on Hegel gave occasion to touch anew upon the question of whether the entry into Appropriation would mean the

end of the history of Being. A similarity with Hegel seems to exist here which must, however, be regarded against the background of a fundamental difference. Whether or not the thesis is justified that one can only speak of an end of history where—as is the case with Hegel—Being and thinking are really identified, remains an open question. In any case, the end of the history of Being in Heidegger's sense is something else. Appropriation does contain possibilities of unconcealment which thinking cannot determine. In this sense, one cannot say that the destinies are "stopped" with the entry of thinking into Appropriation. But one must nevertheless consider whether one can still speak in such a way about Being and the history of Being after the entry, if the history of Being is understood as the history of the destinies in which Appropriation conceals itself.

What was said in an earlier session about ontic models—for example, extending, gift, etc., as ontic occurrences in time—was again taken up. A thinking which thinks in models must not immediately be characterized as technological thinking, because the word "model" is not to be understood in the technological sense as the repetition or project of something in smaller proportions. Rather, a model is that from which thinking must necessarily take off in such a way that that from which it takes off is what gives it an impetus. The necessity for thinking to use models is related to language. The language of thinking can only start from common speech. And speech is fundamentally historico-metaphysical. An interpretation is already built into it. Viewed from this perspective, thinking has only the possibility of searching for models in order to dispense with them eventually, thus making the transition to the speculative. As examples of matters thought with the aid of models we named:

1. the speculative proposition of Hegel which is developed according to the model of the common sentence in such a way that the common sentence provides the model which is to be dispensed with to arrive at the speculative proposition.
2. the manner of movement of *nous* as it is discussed in Plato's *Laws* according to the model of the self-movement of living beings.

What a model as such is and how its function for thinking is to be understood can only be thought from an essential interpretation of language.

Thus the discussions following were concerned with language, more precisely with the relation existing between so-called common speech and the language of thought. Speaking about ontic models presupposes that language in principle has an ontic character, so that thinking finds itself in the situation of having to use ontic models for what it wishes to say ontologically, since it can only make something evident through words.

Even apart from the fact that language is not only ontic, but from the outset ontic-ontological, we can ask whether there cannot be a language of thinking which expresses the *simplicity* of language in such a way that the language of thinking precisely brings to view the limitations of metaphysical language. But about this one cannot talk. The question is decided by success or failure of such Saying. Finally, common language is not the only metaphysical one. Rather, our interpretation of common speech, bound to Greek ontology, also speaks a metaphysical language. But man's relation to language could transform itself analogously to the change of the relation to Being.

At the end of the session, a letter of Heidegger's was read which has been published as the preface to Richardson's book *Heidegger: From Phenomenology to Thought. (Through Phenomenology to Thought,* The Hague). This letter chiefly answers two questions:

1. the first stimulus that determined his thinking, and
2. the question of the turn.

It cleared up the relations at stake in the text being discussed which underlies the path from *Being and Time* to "Time and Being," and from there to Appropriation.

The sixth and last session concerned at first some questions raised, which had to do with the meaning that lies in the words "transformation," "transmutation," when the fullness of the transformation of Being is spoken about. Transformation, transmutation is, on the one hand, predicated within metaphysics about metaphysics. Then the

word means the changing forms in which Being shows itself epochally and historically. The question read: How is the sequence of epochs determined? How does this free sequence determine itself? Why is the sequence precisely this sequence? One is tempted to think of Hegel's history of the "idea." For Hegel, there rules in history necessity which is at the same time freedom. For him, both are one in and through the dialectical movement as the essence of the Spirit exists. For Heidegger, on the other hand, one cannot speak of a "why." Only the "that"—that the history of Being is in such a way—can be said. Thus in the lecture "The Principle of Sufficient Reason" the saying of Goethe is cited:

> How? When? and Where?—The gods remain silent!
> Then stick to *Because,* and ask not about *Why?*

The "because" in the lecture is what endures, what maintains itself as destiny. Within the "that" and in the sense of the "that," thinking can also ascertain something like necessity in the sequence, something like an order and a consistency. Thus one can say that the history of Being is the history of the oblivion of Being escalating itself. Between the epochal transformations of Being and its withdrawal, a relation can be seen which, however, is not a causal relation. One can say that the further one moves away from the beginning of Western thinking, from *aletheia,* the further *aletheia* goes into oblivion; the clearer knowledge, consciousness, comes to the foreground, and Being thus withdraws itself. In addition, this withdrawal of Being remains concealed. In the *kryptesthai* of Heraclitus, that withdrawal is expressed for the first and last time. (*Physis kryptesthai philei.* Nature loves to hide.) The withdrawal of *aletheia* as *aletheia* releases the transformation of Being from *energeia* to *actualitas,* etc.

We must sharply distinguish from this meaning of transformation, which refers to metaphysics, the meaning which is intended when we say that Being is transformed—to Appropriation. Here it is not a matter of manifestation of Being comparable to the metaphysical formations of Being and following them as a new manifestation.

Rather, we mean that Being—together with its epochal revelations —is retained in destiny, but as destiny is taken back into Appropriation.

Between the epochal formations of Being and the transformation of Being into Appropriation stands Framing. Framing is an in-between stage, so to speak. It offers a double aspect, one might say, a Janus head. It can be understood as a kind of continuation of the will to will, thus as an extreme formation of Being. At the same time, however, it is a first form of Appropriation itself.

In the course of the seminar, we often spoke of experiencing. Thus we said among other things: The awakening to Appropriation must be experienced, it cannot be proven. One of the last questions raised concerned the meaning of this experiencing. The question found a kind of contradiction in the fact that thinking was supposed to be the experiencing of the matter itself, and yet on the other hand, is only the preparation for experience. Thus, it was concluded, thinking (and also the thinking attempted in the seminar) is not yet the experience. But what is this experience? Is it the abdication of thinking?

Indeed, thinking and experiencing cannot be contrasted with each other in the manner of alternatives. What happened in the seminar remains an attempt at a preparation for thinking, thus for experiencing. But this preparation occurs already in a thinking manner in that experiencing is nothing mystical, not an act of illumination, but rather the entry into dwelling in Appropriation. Thus awakening to Appropriation remains indeed something which must be experienced, but as such is precisely something which is at first necessarily bound up with the awakening from the oblivion of Being to that oblivion. Thus it remains at first an occurrence which can and must be shown.

The fact that thinking is in a preparatory stage does not mean that the experience is of a different nature from preparatory thinking itself. The limit of preparatory thinking lies elsewhere. On the one hand, in that metaphysics might possibly remain in the last stage of its history in such a way that the other thinking cannot appear at all

—and nevertheless *is.* Then something similar would occur to the thinking that as preparatory thinking looks ahead to Appropriation and can only point—that is, give directives which are to make the direction of the entry to the site of Appropriation possible, somewhat similar to Hölderlin's poetry which was not there for a century —and nevertheless *was.* On the other hand, the limit of thinking lies in that the preparation for *thinking* can only be accomplished in a special respect. It is accomplished in a different way in poetry, too, in art, etc., in which a thinking and speaking also occur.

Afterward "The Turn," taken from the lecture series "Insight into that which is," was read as a conclusion. This was done in order that what was discussed during the seminar might be heard again, so to speak, from another perspective as it were and in a more unified way. Then some questions were raised which were briefly answered.

The denial of world about which "The Turn" speaks is related to the denial and withholding of the present in "Time and Being." For one can also speak about denial and withholding in Appropriation, since they have to do with the manner in which It gives time. The discussion of Appropriation is indeed the site of the farewell from Being and time, but Being and time remain, so to speak, as the gift of Appropriation.

The finitude of Being was first spoken of in the book on Kant. The finitude of Appropriation, of Being, of the fourfold hinted at during the seminar is nevertheless different from the finitude spoken of in the book on Kant,[4] in that it is no longer thought in terms of the relation to infinity, but rather as finitude in itself: finitude, end, limit, one's own—to be secure in one's own. The new concept of finitude is thought in this manner—that is, in terms of Appropriation itself, in terms of the concept of one's own.

But the accused made a sign of refusal. One had to be there, he said, if one was called, but to call oneself was the greatest error that one could make. (Hans Erich Nassack, *Impossible Trial*)

4. *Kant and the Problem of Metaphysics* (Bloomington: Indiana University Press, 1962). Even in "Being and Time" Heidegger thinks temporality as *finite.* (Tr.)

The End of Philosophy
and the Task of Thinking

The title designates the attempt at a reflection which persists in questioning. The questions are paths to an answer. If the answer could be given, the answer would consist in a transformation of thinking, not in a propositional statement about a matter at stake.

The following text belongs to a larger context. It is the attempt undertaken again and again ever since 1930 to shape the question of Being and Time in a more primal way. This means: to subject the point of departure of the question in *Being and Time* to an immanent criticism. Thus it must become clear to what extent the *critical* question of what the matter of thinking is, necessarily and continually belongs to thinking. Accordingly, the name of the task of *Being and Time* will change.

We are asking:

1. What does it mean that philosophy in the present age has entered its final stage?
2. What task is reserved for thinking at the end of philosophy?

1. *What does it mean that philosophy in the present age has entered its final stage?*

Philosophy is metaphysics. Metaphysics thinks being as a whole—

55

the world, man, God—with respect to Being, with respect to the belonging together of beings in Being. Metaphysics thinks beings as being in the manner of representational thinking which gives reasons. For since the beginning of philosophy and with that beginning, the Being of beings has showed itself as the ground (*arche, aition*). The ground is from where beings as such are what they are in their becoming, perishing and persisting as something that can be known, handled and worked upon. As the ground, Being brings beings to their actual presencing. The ground shows itself as presence. The present of presence consists in the fact that it brings what is present each in its own way to presence. In accordance with the actual kind of presence, the ground has the character of grounding as the ontic causation of the real, as the transcendental making possible of the objectivity of objects, as the dialectical mediation of the movement of the absolute Spirit, of the historical process of production, as the will to power positing values.

What characterizes metaphysical thinking which grounds the ground for beings is the fact that metaphysical thinking departs from what is present in its presence, and thus represents it in terms of its ground as something grounded.

What is meant by the talk about the end of philosophy? We understand the end of something all too easily in the negative sense as a mere stopping, as the lack of continuation, perhaps even as decline and impotence. In contrast, what we say about the end of philosophy means the completion of metaphysics. However, completion does not mean perfection as a consequence of which philosophy would have to have attained the highest perfection at its end. Not only do we lack any criterion which would permit us to evaluate the perfection of an epoch of metaphysics as compared with any other epoch. The right to this kind of evaluation does not exist. Plato's thinking is no more perfect than Parmenides'. Hegel's philosophy is no more perfect than Kant's. Each epoch of philosophy has its own necessity. We simply have to acknowledge the fact that a philosophy is the way it is. It is not our business to prefer one to the other, as can be the case with regard to various *Weltanschauungen*.

The old meaning of the word "end" means the same as place: "from one end to the other" means: from one place to the other. The end of philosophy is the place, that place in which the whole of philosophy's history is gathered in its most extreme possibility. End as completion means this gathering.

Throughout the whole history of philosophy, Plato's thinking remains decisive in changing forms. Metaphysics is Platonism. Nietzsche characterizes his philosophy as reversed Platonism. With the reversal of metaphysics which was already accomplished by Karl Marx, the most extreme possibility of philosophy is attained. It has entered its final stage. To the extent that philosophical thinking is still attempted, it manages only to attain an epigonal renaissance and variations of that renaissance. Is not then the end of philosophy after all a cessation of its way of thinking? To conclude this would be premature.

As a completion, an end is the gathering into the most extreme possibilities. We think in too limited a fashion as long as we expect only a development of recent philosophies of the previous style. We forget that already in the age of Greek philosophy a decisive characteristic of philosophy appears: the development of sciences within the field which philosophy opened up. The development of the sciences is at the same time their separation from philosophy and the establishment of their independence. This process belongs to the completion of philosophy. Its development is in full swing today in all regions of beings. This development looks like the mere dissolution of philosophy, and is in truth its completion.

It suffices to refer to the independence of psychology, sociology, anthropology as cultural anthropology, to the role of logic as logistics and semantics. Philosophy turns into the empirical science of man, of all of what can become the experiential object of his technology for man, the technology by which he establishes himself in the world by working on it in the manifold modes of making and shaping. All of this happens everywhere on the basis and according to the criterion of the scientific discovery of the individual areas of beings.

No prophecy is necessary to recognize that the sciences now establishing themselves will soon be determined and guided by the new fundamental science which is called cybernetics.

This science corresponds to the determination of man as an acting social being. For it is the theory of the steering of the possible planning and arrangement of human labor. Cybernetics transforms language into an exchange of news. The arts become regulated-regulating instruments of information.

The development of philosophy into the independent sciences which, however, interdependently communicate among themselves ever more markedly, is the legitimate completion of philosophy. Philosophy is ending in the present age. It has found its place in the scientific attitude of socially active humanity. But the fundamental characteristic of this scientific attitude is its cybernetic, that is, technological character. The need to ask about modern technology is presumably dying out to the same extent that technology more definitely characterizes and regulates the appearance of the totality of the world and the position of man in it.

The sciences will interpret everything in their structure that is still reminiscent of the origin from philosophy in accordance with the rules of science, that is, technologically. Every science understands the categories upon which it remains dependent for the articulation and delineation of its area of investigation as working hypotheses. Their truth is measured not only by the effect which their application brings about within the progress of research.

Scientific truth is equated with the efficiency of these effects.

The sciences are now taking over as their own task what philosophy in the course of its history tried to present in part, and even there only inadequately, that is, the ontologies of the various regions of beings (nature, history, law, art). The interest of the sciences is directed toward the theory of the necessary structural concepts of the coordinated areas of investigation. "Theory" means now: supposition of the categories which are allowed only a cybernetical function, but denied any ontological meaning. The operational and model

character of representational-calculative thinking becomes domi-
nant.

However, the sciences still speak about the Being of beings in the
unavoidable supposition of their regional categories. They just don't
say so. They can deny their origin from philosophy, but never dis-
pense with it. For in the scientific attitude of the sciences, the docu-
ment of their birth from philosophy still speaks.

The end of philosophy proves to be the triumph of the manipula-
ble arrangement of a scientific-technological world and of the social
order proper to this world. The end of philosophy means: the begin-
ning of the world civilization based upon Western European think-
ing.

But is the end of philosophy in the sense of its development to the
sciences also already the complete realization of all the possibilities
in which the thinking of philosophy was posited? Or is there a *first*
possibility for thinking apart from the *last* possibility which we char-
acterized (the dissolution of philosophy in the technologized
sciences), a possibility from which the thinking of philosophy would
have to start out, but which as philosophy it could nevertheless not
experience and adopt?

If this were the case, then a task would still have to be reserved
for thinking in a concealed way in the history of philosophy from its
beginning to its end, a task accessible neither to philosophy as meta-
physics nor, and even less so, to the sciences stemming from philoso-
phy. Therefore we ask:

2. *What task is reserved for thinking at the end of philosophy?*
 The mere thought of such a task of thinking must sound strange
to us. A thinking which can be neither metaphysics nor science?

A task which has concealed itself from philosophy since its very
beginning, even in virtue of that beginning, and thus has withdrawn
itself continually and increasingly in the time to come?

A task of thinking which—so it seems—includes the assertion that
philosophy has not been up to the matter of thinking and has thus
become a history of mere decline?

Is there not an arrogance in these assertions which desires to put itself above the greatness of the thinkers of philosophy?

This suspicion easily suggests itself. But it can as easily be removed. For every attempt to gain insight into the supposed task of thinking finds itself moved to review the whole of the history of philosophy. Not only this, but it is even forced to think the historicity of that which grants a possible history to philosophy.

Because of this, that supposed thinking necessarily falls short of the greatness of the philosophers. It is less than philosophy. Less also because the direct or indirect effect of this thinking on the public in the industrial age, formed by technology and science, is decisively less possible to this thinking than it was in the case of philosophy.

But above all, the thinking in question remains slight because its task is only of a preparatory, not of a founding character. It is content with awakening a readiness in man for a possibility whose contour remains obscure, whose coming remains uncertain.

Thinking must first learn what remains reserved and in store for thinking to get involved in. It prepares its own transformation in this learning.

We are thinking of the possibility that the world civilization which is just now beginning might one day overcome the technological-scientific-industrial character as the sole criterion of man's world sojourn. This may happen not of and through itself, but in virtue of the readiness of man for a determination which, whether listened to or not, always speaks in the destiny of man which has not yet been decided. It is just as uncertain whether world civilization will soon be abruptly destroyed or whether it will be stabilized for a long time, in a stabilization, however, which will not rest in something enduring, but rather establish itself in a sequence of changes, each of which presenting the latest fashion.

The preparatory thinking in question does not wish and is not able to predict the future. It only attempts to say something to the present which was already said a long time ago precisely at the beginning of philosophy and for that beginning, but has not been explicitly

thought. For the time being, it must be sufficient to refer to this with the brevity required. We shall take a directive which philosophy offers as an aid in our undertaking.

When we ask about the task of thinking, this means in the scope of philosophy: to determine that which concerns thinking, which is still controversial for thinking, which is the controversy. This is what the word "matter" means in the German language. It designates that with which thinking has to do in the case at hand, in Plato's language *to pragma auto* (cf. "The Seventh Letter" 341 C7).

In recent times, philosophy has of its own accord expressly called thinking "to the things themselves." Let us mention two cases which receive particular attention today. We hear this call "to the things themselves" in the "Preface" which Hegel has placed before his work which was published in 1807, *System of Science,* [1] first part: "The Phenomenology of Spirit." This preface is not the preface to the *Phenomenology,* but to the *System of Science,* to the whole of philosophy. The call "to the things themselves" refers ultimately—and that means: according to the matter, primarily—to the *Science of Logic.*

In the call "to the things themselves," the emphasis lies on the "themselves." Heard superficially, the call has the sense of a rejection. The inadequate relations to the matter of philosophy are rejected. Mere talk about the purpose of philosophy belongs to these relations, but so does mere reporting about the results of philosophical thinking. Both are never the real totality of philosophy. The totality shows itself only in its becoming. This occurs in the developmental presentation of the matter. In the presentation, theme and method coincide. For Hegel, this identity is called: the idea. With the idea, the matter of philosophy "itself" comes to appear. However, this matter is historically determined: subjectivity. With Descartes' *ego cogito,* says Hegel, philosophy steps on firm ground for the first time where it can be at home. If the *fundamentum absolutum* is attained with the *ego cogito* as the distinctive *subiectum,* this means: The subject is the *hypokeimenon* which is transferred to consciousness,

1. *Wissenschaft, scientia,* body of knowledge, not "science" in the present use of that word. For German Idealism, science is the name for philosophy. (Tr.)

what is truly present, what is unclearly enough called "substance" in traditional language.

When Hegel explains in the Preface (ed. Hoffmeister, p. 19), "The true (in philosophy) is to be understood and expressed not as substance, but just as much as subject," then this means: The Being of beings, the presence of what is present, is only manifest and thus complete presence when it becomes present as such for itself in the absolute Idea. But since Descartes, *idea* means: *perceptio.* Being's coming to itself occurs in speculative dialectic. Only the movement of the idea, the method, is the matter itself. The call "to the thing itself" requires a philosophical method appropriate in it.

However, what the matter of philosophy should be is presumed to be decided from the outset. The matter of philosophy as metaphysics is the Being of beings, their presence in the form of substantiality and subjectivity.

A hundred years later, the call "to the thing itself" again is uttered in Husserl's treatise *Philosophy as Exact Science.* It was published in the first volume of the journal *Logos* in 1910–11 (pp. 289 ff.). Again, the call has at first the sense of a rejection. But here it aims in another direction than Hegel's. It concerns naturalistic psychology which claims to be the genuine scientific method of investigating consciousness. For this method blocks access to the phenomena of intentional consciousness from the very beginning. But the call "to the thing itself" is at the same time directed against historicism which gets lost in treatises about the standpoints of philosophy and in the ordering of types of philosophical *Weltanschauungen.* About this Husserl says in italics (*ibid.*, p.340): *"The stimulus for investigation must start not with philosophies, but with issues and problems."*

And what is at stake in philosophical investigation? In accordance with the same tradition, it is for Husserl as for Hegel the subjectivity of consciousness. For Husserl, the *Cartesian Meditations* were not only the topic of the Parisian lectures in February, 1920. Rather, since the time following the *Logical Investigations,* their spirit accompanied the impassioned course of his philosophical investigations to the end. In its negative and also in its positive sense, the call "to the

thing itself" determines the securing and development of method. It also determines the procedure of philosophy by means of which the matter itself can be demonstrated as a datum. For Husserl, "the principle of all principles" is first of all not a principle of content, but one of method. In his work published in 1913,[2] Husserl devoted a special section (section 24) to the determination of "the principle of all principles." "No conceivable theory can upset this principle," says Husserl (*ibid.*, p. 44).

"The principle of all principles" reads:

that very primordial dator Intuition is a source of authority (Rechtsquelle) for knowledge, that whatever presents itself in "Intuition" in primordial form (as it were in its bodily reality), is simply to be accepted as it gives itself out to be, though only within the limits in which it then presents itself.

"The principle of all principles" contains the thesis of the precedence of method. This principle decides what matter alone can suffice for the method. "The principle of principles" requires reduction to absolute subjectivity as the matter of philosophy. The transcendental reduction to absolute subjectivity gives and secures the possibility of grounding the objectivity of all objects (the Being of this being) in its valid structure and consistency, that is, in its constitution, in and through subjectivity. Thus transcendental subjectivity proves to be "the sole absolute being" (*Formal and Transcendental Logic,* 1929, p. 240). At the same time, transcendental reduction as the method of "universal science" of the constitution of the Being of beings has the same mode of being as this absolute being, that is, the manner of the matter most native to philosophy. The method is not only directed toward the matter of philosophy. It does not just belong to the matter as a key belongs to a lock. Rather, it belongs to the matter because it is "the matter itself." If one wanted to ask: Where does "the principle of all principles" get its unshakable right, the answer would have to be: from transcendental subjectivity which is already presupposed as the matter of philosophy.

We have chosen a discussion of the call "to the thing itself" as our

2. English edition: *Ideas* (New York: Collier Books, 1962). (Tr.)

guideline. It was to bring us to the path which leads us to a determination of the task of thinking at the end of philosophy. Where are we now? We have arrived at the insight that for the call "to the thing itself," what concerns philosophy as its matter is established from the outset. From the perspective of Hegel and Husserl—and not only from their perspective—the matter of philosophy is subjectivity. It is not the matter as such that is controversial for the call, but rather its presentation by which the matter itself becomes present. Hegel's speculative dialectic is the movement in which the matter as such comes to itself, comes to its own presence. Husserl's method is supposed to bring the matter of philosophy to its ultimately originary givenness, that means: to its own presence.

The two methods are as different as they could possibly be. But the matter as such which they are to present is the same, although it is experienced in different ways.

But of what help are these discoveries to us in our attempt to bring the task of thinking to view? They don't help us at all as long as we do not go beyond a mere discussion of the call and ask what remains unthought in the call "to the thing itself." Questioning in this way, we can become aware how something which it is no longer the matter of philosophy to think conceals itself precisely where philosophy has brought its matter to absolute knowledge and to ultimate evidence.

But what remains unthought in the matter of philosophy as well as in its method? Speculative dialectic is a mode in which the matter of philosophy comes to appeal of itself and for itself, and thus becomes presence. Such appearance necessarily occurs in some light. Only by virtue of light, i.e., through brightness, can what shines show itself, that is, radiate. But brightness in its turn rests upon something open, something free which might illuminate it here and there, now and then. Brightness plays in the open and wars there with darkness. Wherever a present being encounters another present being or even only lingers near it—but also where, as with Hegel, one being mirrors itself in another speculatively—there openness already rules, open region is in play. Only this openness

grants to the movement of speculative thinking the passage through that which it thinks.

We call this openness which grants a possible letting-appear and show "opening." In the history of language, the German word "opening" is a borrowed translation of the French *clairière*. It is formed in accordance with the older words *Waldung* (foresting) and *Feldung* (fielding).

The forest clearing (opening) is experienced in contrast to dense forest, called "density" (*Dickung*) in older language. The substantive "opening" goes back to the verb "to open." The adjective *licht* "open" is the same word as "light." To open something means: To make something light, free and open, e.g., to make the forest free of trees at one place. The openness thus originating is the clearing. What is light in the sense of being free and open has nothing in common with the adjective "light," meaning "bright"—neither linguistically nor factually.[3] This is to be observed for the difference between openness and light. Still, it is possible that a factual relation between the two exists. Light can stream into the clearing, into its openness, and let brightness play with darkness in it. But light never first creates openness. Rather, light presupposes openness. However, the clearing, the opening, is not only free for brightness and darkness, but also for resonance and echo, for sounding and diminishing of sound. The clearing is the open for everything that is present and absent.

It is necessary for thinking to become explicitly aware of the matter called opening here. We are not extracting mere notions from mere words, e.g., "opening," as it might easily appear on the surface. Rather, we must observe the unique matter which is adequately named with the name "opening." What the word designates in the connection we are now thinking, free openness, is a "primal phenomenon," to use a word of Goethe's. We would have to say a primal matter. Goethe notes (*Maxims and Reflections*, n. 993): "Look for nothing behind phenomena: they themselves are what is to be

3. Both meanings exist in English for light. The meaning Heidegger intends is related to lever (i.e., alleviate, lighten a burden). (Tr.)

learned." This means: The phenomenon itself, in the present case the opening, sets us the task of learning from it while questioning it, that is, of letting it say something to us.

Accordingly, we may suggest that the day will come when we will not shun the question whether the opening, the free open, may not be that within which alone pure space and ecstatic time and everything present and absent in them have the place which gathers and protects everything.

In the same way as speculative dialectical thinking, originary intuition and its evidence remain dependent upon openness which already dominates, upon the opening. What is evident is what can be immediately intuited. *Evidentia* is the word which Cicero uses to translate the Greek *enargeia*, that is, to transform it into the Roman. *Enargeia*, which has the same root as *argentum* (silver), means that which in itself and of itself radiates and brings itself to light. In the Greek language, one is not speaking about the action of seeing, about *videre*, but about that which gleams and radiates. But it can only radiate if openness has already been granted. The beam of light does not first create the opening, openness, it only traverses it. It is only such openness that grants to giving and receiving at all what is free, that in which they can remain and must move.

All philosophical thinking which explicitly or inexplicitly follows the call "to the thing itself" is already admitted to the free space of the opening in its movement and with its method. But philosophy knows nothing of the opening. Philosophy does speak about the light of reason, but does not heed the opening of Being. The *lumen naturale*, the light of reason, throws light only on openness. It does concern the opening, but so little does it form it that it needs it in order to be able to illuminate what is present in the opening. This is true not only of philosophy's *method*, but also and primarily of its *matter*, that is, of the presence of what is present. To what extent the *subiectum*, the *hypokeimenon*, that which already lies present, thus what is present in its presence is constantly thought also in subjectivity cannot be shown here in detail. Refer to Heidegger, *Nietzsche*, vol. 2 (1961), pages 429 ff.

We are concerned now with something else. Whether or not what
is present is experienced, comprehended or presented, presence as
lingering in openness always remains dependent upon the prevalent
opening. What is absent, too, cannot be as such unless it presences
in the *free space of the opening.*

All metaphysics including its opponent positivism speaks the lan-
guage of Plato. The basic word of its thinking, that is, of his presenta-
tion of the Being of beings, is *eidos, idea:* the outward appearance in
which beings as such show themselves. Outward appearance, how-
ever, is a manner of presence. No outward appearance without light
—Plato already knew this. But there is no light and no brightness
without the opening. Even darkness needs it. How else could we
happen into darkness and wander through it? Still, the opening as
such as it prevails through Being, through presence, remains un-
thought in philosophy, although the opening is spoken about in
philosophy's beginning. How does this occur and with which
names? Answer:

In Parmenides' reflective poem which, as far as we know, was the
first to reflect explicitly upon the Being of beings, which still today,
although unheard, speaks in the sciences into which philosophy
dissolves. Parmenides listens to the claim:

> . . . *kreo de se panta puthestha*
> *emen aletheies eukukleos atremes etor*
> *ede broton doxas, tais ouk emi pistis alethes.*
> Fragment I, 28 ff.
> . . . but you should learn all:
> the untrembling heart of unconcealment, well-rounded
> and also the opinions of mortals,
> lacking the ability to trust what is unconcealed.[4]

Aletheia, unconcealment, is named here. It is called well-rounded
because it is turned in the pure sphere of the circle in which begin-

4. Standard translation: "It is needful that you should learn of all matters—both
the unshaken heart of well-rounded truth and the opinions of mortals which
lack true belief." (Tr.)

ning and end are everywhere the same. In this turning, there is no possibility of twisting, deceit and closure. The meditative man is to experience the untrembling heart of unconcealment. What does the word about the untrembling heart of unconcealment mean? It means unconcealment itself in what is most its own, means the place of stillness which gathers in itself what grants unconcealment to begin with. That is the opening of what is open. We ask: openness for what? We have already reflected upon the fact that the path of thinking, speculative and intuitive, needs the traversable opening. But in that opening rests possible radiance, that is, the possible presencing of presence itself.

What prior to everything else first grants unconcealment in the path on which thinking pursues one thing and perceives it: *hotos estin . . . einai:* that presence presences. The opening grants first of all the possibility of the path to presence, and grants the possible presencing of that presence itself. We must think *aletheia,* unconcealment, as the opening which first grants Being and thinking and their presencing to and for each other. The quiet heart of the opening is the place of stillness from which alone the possibility of the belonging together of Being and thinking, that is, presence and perceiving, can arise at all.

The possible claim to a binding character or commitment of thinking is grounded in this bond. Without the preceding experience of *aletheia* as the opening, all talk about committed and non-committed thinking remains without foundation. Where does Plato's determination of presence as *idea* have its binding character from? With regard to what is Aristotle's interpretation of presencing as *energeia* binding?

Strangely enough, we cannot even ask these questions always neglected in philosophy as long as we have not experienced what Parmenides had to experience: *aletheia,* unconcealment. The path to it is distinguished from the street on which the opinion of mortals must wander around. *Aletheia* is nothing mortal, just as little as death itself.

It is not for the sake of etymology that I stubbornly translate the name *aletheia* as unconcealment, but for the matter which must be

considered when we think that which is called Being and thinking adequately. Unconcealment is, so to speak, the element in which Being and thinking and their belonging together exist. *Aletheia* is named at the beginning of philosophy, but afterward it is not explicitly thought as such by philosophy. For since Aristotle it became the task of philosophy as metaphysics to think beings as such onto-theologically.

If this is so, we have no right to sit in judgment over philosophy, as though it left something unheeded, neglected it and was thus marred by some essential deficiency. The reference to what is unthought in philosophy is not a criticism of philosophy. If a criticism is necessary now, then it rather concerns the attempt which is becoming more and more urgent ever since *Being and Time* to ask about a possible task of thinking at the end of philosophy. For the question now arises, late enough: Why is *aletheia* not translated with the usual name, with the word "truth"? The answer must be:

Insofar as truth is understood in the traditional "natural" sense as the correspondence of knowledge with beings demonstrated in beings, but also insofar as truth is interpreted as the certainty of the knowledge of Being, *aletheia,* unconcealment in the sense of the opening may not be equated with truth. Rather, *aletheia,* unconcealment thought as opening, first grants the possibility of truth. For truth itself, just as Being and thinking, can only be what it is in the element of the opening. Evidence, certainty in every degree, every kind of verification of *veritas* already move *with* that *veritas* in the realm of the prevalent opening.

Aletheia, unconcealment thought as the opening of presence, is not yet truth. Is *aletheia* then less than truth? Or is it more because it first grants truth as *adequatio* and *certitudo,* because there can be no presence and presenting outside of the realm of the opening?

This question we leave to thinking as a task. Thinking must consider whether it can even raise this question at all as long as it thinks philosophically, that is, in the strict sense of metaphysics

which questions what is present only with regard to its presence.

In any case, one thing becomes clear: To raise the question of *aletheia,* of unconcealment as such, is not the same as raising the question of truth. For this reason, it was inadequate and misleading to call *aletheia* in the sense of opening, truth.[5] The talk about the "truth of Being" has a justified meaning in Hegel's *Science of Logic,* because here truth means the certainty of absolute knowledge. But Hegel also, as little as Husserl, as little as all metaphysics, does not ask about Being as Being, that is, does not raise the question how there can be presence as such. There is presence only when opening is dominant. Opening is named with *aletheia,* unconcealment, but not thought as such.

The natural concept of truth does not mean unconcealment, not in the philosophy of the Greeks either. It is often and justifiably pointed out that the word *alethes* is already used by Homer only in the *verba dicendi,* in statement and thus in the sense of correctness and reliability, not in the sense of unconcealment. But this reference means only that neither the poets nor everyday language usage, not even philosophy see themselves confronted with the task of asking how truth, that is, the correctness of statements, is granted only in the element of the opening of presence.

In the scope of this question, we must acknowledge the fact that *aletheia,* unconcealment in the sense of the opening of presence, was originally only experienced as *orthotes,* as the correctness of representations and statements. But then the assertion about the essential transformation of truth, that is, from unconcealment to correctness, is also untenable.[6]

5. How the attempt to think a matter can at times stray from that which a decisive insight has already shown, is demonstrated by a passage from *Being and Time* (1927) (p. 262, New York: Harper & Row, 1962). To translate this word *(aletheia)* as "truth," and, above all, to define this expression conceptually in theoretical ways, is to cover up the meaning of what the Greeks made "self-evidently" basic for the terminological use of aletheia as a prephilosophical way of understanding it.

6. This statement has profound implications for Heidegger's book *Platons Lehre von der Wahrheit.* (Tr.)

Instead we must say: *Aletheia,* as opening of presence and presenting in thinking and saying, originally comes under the perspective of *homoiosis and adaequatio,* that is, the perspective of adequation in the sense of the correspondence of representing with what is present.

But this process inevitably provokes another question: How is it that *aletheia,* unconcealment, appears to man's natural experience and speaking *only* as correctness and dependability? Is it because man's ecstatic sojourn in the openness of presencing is turned only toward what is present and the existent presenting of what is present? But what else does this mean than that presence as such, and together with it the opening granting it, remain unheeded? Only what *aletheia* as opening grants is experienced and thought, not what it is as such.

This remains concealed. Does this happen by chance? Does it happen only as a consequence of the carelessness of human thinking? Or does it happen because self-concealing, concealment, *lethe* belongs to *a-letheia,* not just as an addition, not as shadow to light, but rather as the heart of *aletheia?* And does not even a keeping and preserving rule in this self-concealing of the opening of presence from which unconcealment can be granted to begin with, and thus what is present can appear in its presence?

If this were so, then the opening would not be the mere opening of presence, but the opening of presence concealing itself, the opening of a self-concealing sheltering.

If this were so, then with these questions we would reach the path to the task of thinking at the end of philosophy.

But isn't this all unfounded mysticism or even bad mythology, in any case a ruinous irrationalism, the denial of *ratio?*

I return to the question: What does *ratio, nous, noein,* perceiving *(Vernunft—Vernehmen)* mean? What does ground and principle and especially principle of all principles mean? Can this ever be sufficiently determined unless we experience *aletheia* in a Greek manner as unconcealment and then, above and beyond the Greek, think it as the opening of self-concealing? As long as *ratio* and the rational

still remain questionable in what is their own, talk about irrational-
ism is unfounded. The technological scientific rationalization ruling
the present age justifies itself every day more surprisingly by its
immense results. But these results say nothing about what the possi-
bility of the rational and the irrationaal first grants. The effect proves
the correctness of technological scientific rationalization. But is the
manifest character of what-is exhausted by what is demonstrable?
Doesn't the insistence on what is demonstrable block the way to
what-is?

Perhaps there is a thinking which is more sober than the irresist-
ible race of rationalization and the sweeping character of cybernet-
ics. Presumably it is precisely this sweeping quality which is ex-
tremely irrational.

Perhaps there is a thinking outside of the distinction of rational
and irrational still more sober than scientific technology, more sober
and thus removed, without effect and yet having its own necessity.
When we ask about the task of this thinking, then not only this
thinking, but also the question about it is first made questionable. In
view of the whole philosophical tradition, this means:

We all still need an education in thinking, and before that first a
knowledge of what being educated and uneducated in thinking
means. In this respect, Aristotle gives us a hint in Book IV of his
Metaphysics (1006a ff.). It reads: *esti gar apaideusia to me gignoskein
tinon dei zetein apodeixin kai tinon ou dei.* "For it is uneducated not to
have an eye for when it is necessary to look for a proof, and when
this is not necessary."

This sentence demands careful reflection. For it is not yet decided
in what way that which needs no proof in order to become accessible
to thinking is to be experienced. Is it dialectical mediation or origi-
nary intuition or neither of the two? Only the peculiar quality of that
which demands of us above all else to be admitted can decide about
that. But how is this to make the decision possible for us before we
have not admitted it? In what circle are we moving here, inevitably?

Is it the *eukukleos alethein,* well-founded unconcealment itself,
thought as the opening?

Does the name for the task of thinking then read instead of *Being and Time:* Opening and Presence?

But where does the opening come from and how is it given? What speaks in the "It gives"?

The task of thinking would then be the surrender of previous thinking to the determination of the matter of thinking.

My Way to Phenomenology

My academic studies began in the winter of 1909–10 in theology at the University of Freiburg. But the chief work for the study in theology still left enough time for philosophy which belonged to the curriculum anyhow. Thus both volumes of Husserl's *Logical Investigations* lay on my desk in the theological seminary ever since my first semester there. These volumes belonged to the university library. The date due could be easily renewed again and again. The work was obviously of little interest to the students. But how did it get into this environment so foreign to it?

I had learned from many references in philosophical periodicals that Husserl's thought was determined by Franz Brentano. Ever since 1907, Brentano's dissertation "On the manifold meaning of being since Aristotle" (1862) had been the chief help and guide of my first awkward attempts to penetrate into philosophy. The following question concerned me in a quite vague manner: If being is predicated in manifold meanings, then what is its leading fundamental meaning? What does Being mean? In the last year of my stay at the *Gymnasium,* I stumbled upon the book of Carl Braig, then professor for dogmatics at Freiburg University: "On Being. Outline of Ontology." It had been published in 1896 at the time when he was

an associate professor at Freiburg's theological faculty. The larger sections of the work give extensive text passages from Aristotle, Thomas of Aquinas and Suarez, always at the end, and in addition the etymology for fundamental ontological concepts.

From Husserl's *Logical Investigations,* I expected a decisive aid in the questions stimulated by Brentano's dissertation. Yet my efforts were in vain because I was not searching in the right way. I realized this only very much later. Still, I remained so fascinated by Husserl's work that I read in it again and again in the years to follow without gaining sufficient insight into what fascinated me. The spell emanating from the work extended to the outer appearance of the sentence structure and the title page. On that title page I encountered the name of the publisher Max Niemeyer. This encounter is before my eyes as vividly today as then. His name was connected with that of "Phenomenology," then foreign to me, which appears in the subtitle of the second volume. My understanding of the term "phenomenology" was just as limited and vacillating as my knowledge in those years of the publisher Max Niemeyer and his work. Why and how both names—Niemeyer Publishing House and Phenomenology— belong together would soon become clearer.

After four semesters I gave up my theological studies and dedicated myself entirely to philosophy. I still attended theological lectures in the years following 1911, Carl Braig's lecture course on dogmatics. My interest in speculative theology led me to do this, above all the penetrating kind of thinking which this teacher concretely demonstrated in every lecture hour. On a few walks when I was allowed to accompany him, I first heard of Schelling's and Hegel's significance for speculative theology as distinguished from the dogmatic system of Scholasticism. Thus the tension between ontology and speculative theology as the structure of metaphysics entered the field of my search.

Yet at times this realm faded to the background compared with that which Heinrich Rickert treated in his seminars: the two writings of his pupil Emil Lask who was killed as a simple soldier on the Galician front in 1915. Rickert dedicated the third fully revised

edition of his work *The Object of Knowledge, Introduction to Transcenden-*
tal Philosophy, which was published the same year, "to my dear
friend." The dedication was supposed to testify to the teacher's
benefit derived from this pupil. Both of Emil Lask's writings—*The*
Logic of Philosophy and the Doctrine of Categories, A Study of the Dominant
Realm of Logical Form (1911) and *The Doctrine of Judgment* (1912)—
themselves showed clearly enough the influence of Husserl's *Logical*
Investigations.

These circumstances forced me to delve into Husserl's work
anew. However, my repeated beginning also remained unsatisfac-
tory, because I couldn't get over a main difficulty. It concerned the
simple question how thinking's manner of procedure which called
itself "phenomenology" was to be carried out. What worried me
about this question came from the ambiguity which Husserl's work
showed at first glance.

The first volume of the work, published in 1900, brings the refuta-
tion of psychologism in logic by showing that the doctrine of thought
and knowledge cannot be based on psychology. In contrast, the
second volume, which was published the following year and was
three times as long, contains the description of the acts of conscious-
ness essential for the constitution of knowledge. So it is a psychology
after all. What else is section 9 of the fifth investigation concerning
"The Meaning of Brentano's Delimitation of 'psychical
phenomena' "? Accordingly, Husserl falls back with his
phenomenological description of the phenomena of consciousness
into the position of psychologism which he had just refuted. But if
such a gross error cannot be attributed to Husserl's work, then what
is the phenomenological description of the acts of consciousness?
Wherein does what is peculiar to phenomenology consist if it is
neither logic nor psychology? Does a quite new discipline of philoso-
phy appear here, even one with its own rank and precedence?

I could not disentangle these questions. I remained without know-
ing what to do or where to go. I could hardly even formulate the
questions with the clarity in which they are expressed here.

The year 1913 brought an answer. The *Yearbook for Philosophy and*

Phenomenological Investigation which Husserl edited began to be published by the publisher Max Niemeyer. The first volume begins with Husserl's treatise *Ideas*.

"Pure phenomenology" is the "fundamental science" of philosophy which is characterized by that phenomenology. "Pure" means: "transcendental phenomenology." However, the "subjectivity" of the knowing, acting and valuing subject is posited as "transcendental." Both terms, "subjectivity" and "transcendental," show that "phenomenology" consciously and decidedly moved into the tradition of modern philosophy but in such a way that "transcendental subjectivity" attains a more original and universal determination through phenomenology. Phenomenology retained "experiences of consciousness" as its thematic realm, but now in the systematically planned and secured investigation of the structure of acts of experience together with the investigation of the objects experienced in those acts with regard to their objectivity.

In this universal project for a phenomenological philosophy, the *Logical Investigations*, too—which had so to speak remained philosophically neutral—could be assigned their systematic place. They were published in the same year (1913) in a second edition by the same publisher. Most of the investigations had in the meantime undergone "profound revisions." The sixth investigation, "the most important with regard to phenomenology" (preface to the second edition) was, however, withheld. But the essay "Philosophy as Exact Science" (1910-11) which Husserl contributed to the first volume of the new journal *Logos* also only now acquired a sufficient basis for its programmatical theses through the *Ideas*.

In virtue of these publications, Niemeyer's work attained the foremost rank of philosophical publishers. At that time the rather obvious idea was current that with "phenomenology" a new school had arisen in European philosophy. Who could have denied the correctness of this statement?

But such historical calculation did not comprehend what had happened in virtue of "phenomenology," that is, already with the *Logical Investigations*. This remained unspoken, and can hardly even be

rightly expressed today. Husserl's own programmatical explanations and methodological presentations rather strengthened the misunderstanding that through "phenomenology" a beginning of philosophy was claimed which denied all previous thinking.

Even after the *Ideas* was published, I was still captivated by the never-ceasing spell of the *Logical Investigations.* That magic brought about anew an unrest unaware of its own reason, although it made one suspect that it came from the inability to attain the act of philosophical thinking called "phenomenology" simply by reading the philosophical literature.

My perplexity decreased slowly, my confusion dissolved laboriously, only after I met Husserl personally in his workshop.

Husserl came to Freiburg in 1916 as Heinrich Rickert's successor. Rickert had taken over Windelband's chair in Heidelberg. Husserl's teaching took place in the form of a step-by-step training in phenomenological "seeing" which at the same time demanded that one relinquish the untested use of philosophical knowledge. But it also demanded that one give up introducing the authority of the great thinkers into the conversation. However, the clearer it became to me that the increasing familiarity with phenomenological seeing was fruitful for the interpretation of Aristotle's writing, the less I could separate myself from Aristotle and the other Greek thinkers. Of course I could not immediately see what decisive consequences my renewed occupation with Aristotle was to have.

As I myself practiced phenomenological seeing, teaching and learning in Husserl's proximity after 1919 and at the same time tried out a transformed understanding of Aristotle in a seminar, my interest leaned anew toward the *Logical Investigations,* above all the sixth investigation in the first edition. The distinction which is worked out there between sensuous and categorial intuition revealed itself to me in its scope for the determination of the "manifold meaning of being."

For this reason we—friends and pupils—begged the master again and again to republish the sixth investigation which was then difficult to obtain. True to his dedication to the cause of phenomenology, the

publisher Niemeyer published the last chapter of the *Logical Investigations* again in 1922. Husserl notes in the preface: "As things stand, I had to give in to the wishes of the friends of this work and decide to make its last chapter available again in its old form." With the phrase "the friends of this work," Husserl also wanted to say that he himself could not quite get close to the *Logical Investigations* after the publication of the *Ideas.* At the new place of his academic activity, the passion and effort of his thought turned toward the systematic development of the plan presented in the *Ideas* more than ever. Thus Husserl could write in the preface mentioned to the sixth investigation: "My teaching activity in Freiburg, too, furthered the direction of my interest toward general problems and the system."

Thus Husserl watched me in a generous fashion, but at the bottom in disagreement, as I worked on the *Logical Investigations* every week in special seminars with advanced students in addition to my lectures and regular seminars. Especially the preparation for this work was fruitful for me. There I learned one thing—at first rather led by surmise than guided by founded insight: What occurs for the phenomenology of the acts of consciousness as the self-manifestation of phenomena is thought more originally by Aristotle and in all Greek thinking and existence as *aletheia,* as the unconcealedness of what-is present, its being revealed, its showing itself. That which phenomenological investigations rediscovered as the supporting attitude of thought proves to be the fundamental trait of Greek thinking, if not indeed of philosophy as such.

The more decisively this insight became clear to me, the more pressing the question became: Whence and how is it determined what must be experienced as "the things themselves" in accordance with the principle of phenomenology? Is it consciousness and its objectivity or is it the Being of beings in its unconcealedness and concealment?

Thus I was brought to the path of the question of Being, illumined by the phenomenological attitude, again made uneasy in a different way than previously by the questions prompted by Brentano's dissertation. But the path of questioning became longer than I suspected.

It demanded many stops, detours and wrong paths. What the first lectures in Freiburg and then in Marburg attempted shows the path only indirectly.

"Professor Heidegger—you have got to publish something now. Do you have a manuscript?" With these words the dean of the philosophical faculty in Marburg came into my study one day in the winter semester of 1925-26. "Certainly," I answered. Then the dean said: "But it must be printed quickly." The faculty proposed me *unico loco* as Nicolai Hartmann's successor for the chief philosophical chair. Meanwhile, the ministry in Berlin had rejected the proposal with the explanation that I had not published anything in the last ten years.

Now I had to submit my closely protected work to the public. On account of Husserl's intervention, the publishing house Max Niemeyer was ready to print immediately the first fifteen proof sheets of the work which was to appear in Husserl's *Jahrbuch*. Two copies of the finished page proofs were sent to the ministry by the faculty right away. But after some time, they were returned to the faculty with the remark: "Inadequate." In February of the following year (1927), the complete text of *Being and Time* was published in the eighth volume of the *Jahrbuch* and as a separate publication. After that the ministry reversed its negative judgment half a year later and made the offer for the chair.

On the occasion of the strange publication of *Being and Time*, I came first into direct relationship with the publishing house Max Niemeyer. What was a mere name on the title page of Husserl's fascinating work during the first semester of my academic studies became evident now and in the future in all the thoroughness and reliability, generosity and simplicity, of publication work.

In the summer of 1928, during my last semester in Marburg, the *Festschrift* for Husserl's seventieth birthday was in preparation. At the beginning of this semester Max Scheler died unexpectedly. He was one of the co-editors of Husserl's *Jahrbuch* where he published his great investigation *Formalism in Ethics and Material Ethics of Value*

in the first and second volume (1916). Along with Husserl's *Ideas,* it must count as the most significant contribution to the *Jahrbuch.* Through its far-reaching effects, it placed the scope and effectiveness of the Niemeyer publishing house in a new light.

The *Festschrift* for Edmund Husserl appeared punctually for his birthday as a supplement to the *Jahrbuch.* I had the honor of presenting it to the celebrated teacher within a circle of his pupils and friends on April 8, 1929.

During the following decade all more extensive publications were withheld until the publishing house Niemeyer dared to print my interpretation of Hölderlin's hymn "As on a Holiday" in 1941 without giving the year of publication. I had given this lecture in May of the same year as a public guest lecture at the university of Leipzig. The owner of the publishing house, Mr. Hermann Niemeyer, had come from Halle to hear this lecture. Afterward we discussed the publication.

When I decided twelve years later to publish earlier lecture series, I chose the Niemeyer publishing house for this purpose. It no longer bore the designation "Halle a.d. Saale." Following great losses and manifold difficulties, and visited by hard personal suffering, the present owner had re-established the firm in Tübingen.

"Halle a.d. Saale"—in the same city, the former *Privatdozent* Edmund Husserl taught during the '90's of the last century at that university. Later in Freiburg, he often told the story of how the *Logical Investigations* came to be. He never forgot to remember the Max Niemeyer publishing house with gratitude and admiration, the house which took upon itself the venture of publishing, at the turn of the century, an extensive work of a little-known instructor who went his own new ways and thus had to estrange contemporary philosophy, which ignored the work for years after its appearance, until Wilhelm Dilthey recognized its significance. The publishing house could not know at that time that his name would remain tied to that of phenomenology in the future, that phenomenology would soon determine the spirit of the age in the most various realms— mostly in a tacit manner.

And today? The age of phenomenological philosophy seems to be over. It is already taken as something past which is only recorded historically along with other schools of philosophy. But in what is most its own phenomenology is not a school. It is the possiblity of thinking, at times changing and only thus persisting, of corresponding to the claim of what is to be thought. If phenomenology is thus experienced and retained, it can disappear as a designation in favor of the matter of thinking whose manifestness remains a mystery.

Supplement 1969

In the sense of the last sentence, on can already read in *Being and Time* (1927) pp. 62-63: "its (phenomenology's) essential character does not consist in being *actual* as a philosophical school. Higher than actuality stands *possibility*. The comprehension of phenomenology consists solely in grasping it as possibility."

References

The lecture "Time and Being" was given on January 31, 1962, at the Studium Generale, University of Freiburg im Br, directed by Eugen Fink. In the structure of the treatise *Being and Time* (1927), the title "Time and Being" characterizes the third section of the first part of the treatise. The author was at that time not capable of a sufficient development of the theme designated in the title "Time and Being." The publication of *Being and Time* was interrupted at that point.

What this text contains, written three and a half decades later, can no longer be a continuation of the text of *Being and Time.* The leading question has indeed remained the same, but this simply means: the question has become still more questionable and still more alien to the spirit of the times. (The sections in parentheses in the text were written at the same time as the text of the lecture, but were not read.)

The first printing of the German text, together with a French translation by François Fedier, appeared in the *Festschrift* for Jean Beaufret which was issued under the title *L'Endurance de la Pensée* (Endurance of Thinking) 1968 by the publisher Plon, Paris.

The summary of the seminar on the lecture "Time and Being" was

written by Dr. Alfred Guzzoni. I checked the text and supplemented it in some passages. The seminar took place in Todtnauberg (Schwarzwald) from the 11th to the 13th of September 1962 in six sessions. The publication of the summary serves the purpose of clarifying and sharpening what is questionable in the text of the lecture.

The lecture "The End of Philosophy and the Task of Thinking" has until now only been published in a French translation by Jean Beaufret and François Fédier, in a collected volume *Kierkegaard vivant* (Living Kierkegaard), Colloque organisé par L'Unesco à Paris du 21 au 23 avril 1964, Gallimard, Paris, pp. 165 ff.

"My Way to Phenomenology" first appeared in the contribution to the privately printed *Festgabe "Hermann Niemeyer zum achtzigsten Geburtstag, April 16, 1963* (Hermann Niemeyer for his eightieth birthday).

72 73 74 75 76 9 8 7 6 5 4 3 2 1